South Bend

IN VINTAGE POSTCARDS

POSTCARD HISTORY SERIES

South Bend

IN VINTAGE POSTCARDS

John Palmer

ARCADIA

Published by Arcadia Publishing
Charleston SC, Chicago IL, Portsmouth NH, San Francisco CA

Printed in Great Britain

Library of Congress Catalog Card Number: 2005924480

For all general information contact Arcadia Publishing at:
Telephone 843-853-2070
Fax 843-853-0044
E-mail sales@arcadiapublishing.com
For customer service and orders:
Toll-Free 1-888-313-2665

Visit us on the internet at http://www.arcadiapublishing.com

CONTENTS

ACKNOWLEDGMENTS

The author would like to take a few minutes to thank the South Bend Community School Corporation's Department of Buildings and Grounds for their help in researching information on South Bend High School and Studebaker School. The South Bend Park Department deserves a hearty acknowledgement for providing important information on Leeper Park and for providing a copy of Ed Talley's ground-breaking research paper on the history of Leeper Park.

And a special thanks goes to all of the postcard vendors, past and present, of the Midwest Postcard Exposition, who have helped me gather this excellent collection of South Bend history.

INTRODUCTION

I first started collecting postcards when I was in high school, along with collecting coins, books, and a few other hobbies that have gone by the wayside. It wasn't a serious hobby, but I would pick up a few new postcards at odd times at Osco's and Kresge's, and older post cards at 100 Center and the Thieves Market because I liked the pictures. Later, I began attending postcard shows and met many interesting collectors.

I didn't know the history of postcards and didn't care about the differences between private postcards, split and full backs, or any other terminology. But over the years I have learned a little of their history and of the various types, very little of which will appear here.

When I first started collecting postcards, I never paid too much attention to how many copies of the same scene I had gathered, and didn't really try to collect every known postcard of Howard or Leeper or Springbrook Park. The postcards went into boxes, uncataloged and disorganized.

Finally, when I had two large boxes of postcards, I decided that it was time to do something about seeing what I had, and it was an interesting experience.

It didn't take long to see that the Oliver Hotel was the most popular subject. More different views of the Oliver Hotel exist, both interior and exterior, than many other buildings combined. The next most popular subject was the courthouse, quickly followed by Leeper Park.

This is a history of South Bend as viewed in postcards which were printed in the first half of the 20th century, with a few key historical scenes, general buildings, parks, and more. South Bend, for all practical purposes, was an infant town in 1830, its future uncertain. I have taken statistical information from the 1930 South Bend City directory, making a quick comparison to see how much South Bend grew in those 100 years.

A Brief History of South Bend Postcards

Historians usually agree that the pioneer period for postcards began in 1893, when vendors began displaying and selling them at the Columbian Exposition in Chicago. Then, in 1898, the government gave private printers permission to print and sell postcards. These cards are marked with the words "Private Mailing Card." Although still considered a fad by many, collecting and sending postcards became an essential way to send greetings and keep reminders of places which visitors had seen.

Just exactly when the first postcard was issued in South Bend is still not clear, but the *South Bend Tribune* was among the first, if not the first, printer of South Bend postcards, when it began publishing a limited number of them during the summer of 1903. By October 20, 1904, the paper boasted it had published 73 postcards on a variety of subjects.

Notably absent from the paper's listing of historical landmarks, important buildings, and so on were Navarre's Cabin and the Council Oak Tree, which were popular subjects in the 1950s and 1960s. Churches were a common theme. Notre Dame and St. Mary's Academy had a variety of postcards. Banks and manufacturers were also found in the listing. Mishawaka had its share of cards. Leeper Park and Howard Park had a few cards. Absent were cards of lodges and societies.

The same listing of cards was provided in an April 1, 1905 *South Bend Tribune* advertisement. Since no new cards were published, it is not clear whether the *Tribune* felt it had exhausted its listing of important places, or believed the postcard fad was beginning to fade. On the other hand, almost all of the postcards the paper produced had come from photographs appearing in several books it printed, including *South Bend and the Men Who Have Made It*, which was published by the *Tribune* in 1901. Perhaps the *Tribune* was just taking advantage of the opportunity to use stock photographs already on hand.

During this time, other printers began to photograph lodges, hospitals, and scenes.

These real scenes, featured in "real photo post cards," cover a variety of subjects. Among the earliest producers of real photo post cards in South Bend was the Miller Book Store. The American Trust Company found postcards an inexpensive way to advertise its business and published a color card on Sacred Heart Church at the University of Notre Dame.

In October 1909, the Chamber of Commerce sponsored a "Homecoming Day," bringing many visitors to the area. This prompted various printers, in 1908, to begin a series of cards of South Bend sites, including a wide variety of Howard Park, Leeper Park, government buildings, the public library, and churches. Postcards postmarked between 1908 and 1912 are quite common finds.

Other publishers, not from South Bend, soon began to publish their own South Bend cards. Among these printers were C. T. American Art, The Autograph Company of Chicago, and the Indiana News Company.

Both black-and-white and color views of the same postcard can often be found. In addition, color postcards of the same scene may vary in hue. A bank may show up in one postcard as brick red, while on another card the same building is pale yellow.

The color variety is easily explained because photographs were sent to England, Germany, Italy, India, and several other countries to have experts fill in the colors. Sometimes descriptions of the cards were given to the colorists. Sometimes the colorists had only their imagination as a guideline. Because of the varying color schemes, it is sometimes difficult for historians to trust the card completely as to its historical accuracy. Sometimes cards were changed with the simple elimination of people or objects while at other times details not original to the setting were added to the card.

Finally, cards are sometimes incorrectly identified. One postcard showing the "Colfax Street Bridge" is actually the La Salle Street Bridge.

By the 1950s, small South Bend firms such as Mort Linder, Gardner News Agency, and City News Agency were publishing a few cards, followed in the 1960s by Cloetingh and DeMan Studios. The most prolific postcard publisher since the 1960s has been, and still is, John Penrod of Berrien Center, Michigan.

One
STREET SCENES
AND BUSINESSES

Native Americans had settled in South Bend hundreds, perhaps thousands, of years before the first known white settler established a trading post here in 1820. From that first cabin of Pierre Navarre, a town was to eventually take shape. By 1920, the town had grown to 70,983 people. Hundreds of buildings dotted the downtown area, including churches, blacksmiths, clothing and dry goods stores, banks, law offices, commercial buildings, lodges, and hospitals. Pictured here are just a few of the many buildings where our great grandparents worshiped, paid taxes, bought clothes, and spent leisure time.

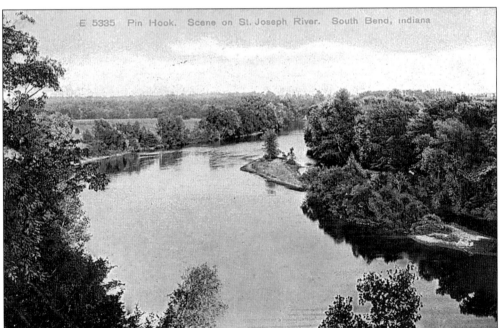

This sharp pin hook curve in the St. Joseph River marks the beginning of the portage from the St. Joseph River over the prairie grass to the Kankakee River, the first step in the long voyage down to the Illinois River, and ultimately, the Mississippi River.

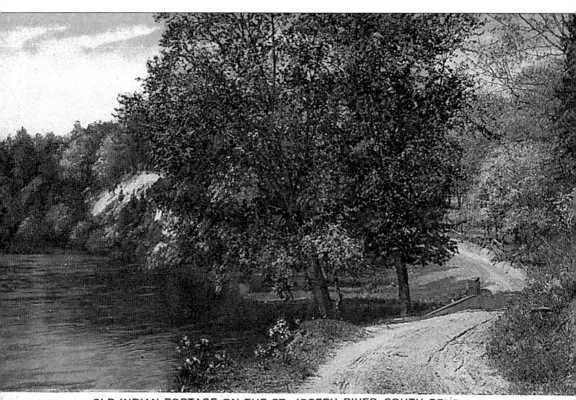

OLD INDIAN PORTAGE ON THE ST. JOSEPH RIVER, SOUTH BEND, INDIANA.
TRAVELED BY LA SALLE ON WAY TO MISSISSIPPI.

South Bend history began thousands of years ago when local Native Americans organized an elaborate trading system. The portage between the St. Joseph River and the Kankakee River continued a trading route that began in Michigan and ended at the mouth of the Mississippi River. Various Native American groups had been using the route for centuries, but the enterprising Frenchman Robert de La Salle claimed its discovery.

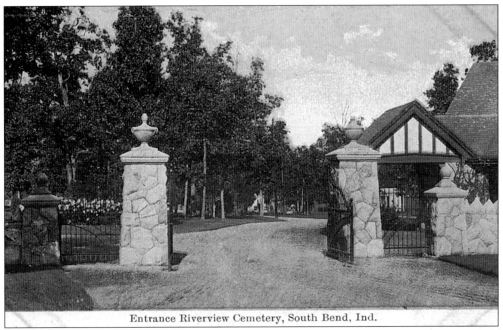

Entrance Riverview Cemetery, South Bend, Ind.

The Riverview Cemetery Association was incorporated in 1900 with a working capital of $50,000, and shortly thereafter purchased the farm land of James R. Miller between Portage Avenue and the St. Joseph River. Riverview Cemetery originally contained 50 acres. The entrance is made of field stone, while an entrance building combined both an office and a chapel. This entrance has changed very little since 1900. Down to the left, and not far from the entrance, you can still walk the steep portage trail that leads up from the St. Joseph River.

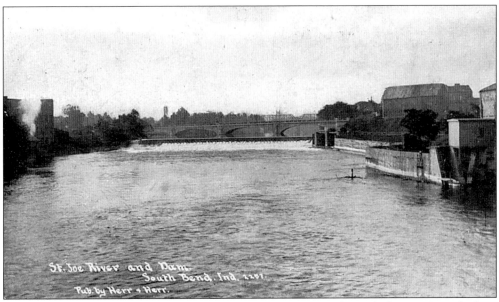

The St. Joseph River has played the most important part in South Bend's history. In early days, it brought traders and boats. When it was harnessed with a dam in 1843, the river provided energy to drive turbines and powered manufacturing plants on the East and West Races.

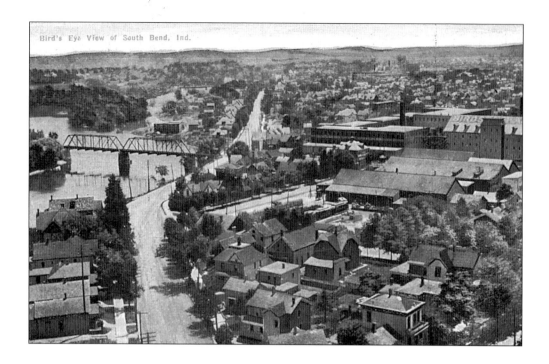

These two views show Vistula Avenue (now Lincoln Way East) about 20 years apart. The top view was taken about 1910, while the lower view was taken around 20 years later. The bridge over the St. Joseph River was a railroad bridge. This street originally began as an ancient Indian trail beginning near Vistula, Ohio, and continuing westward through Indiana and Illinois.

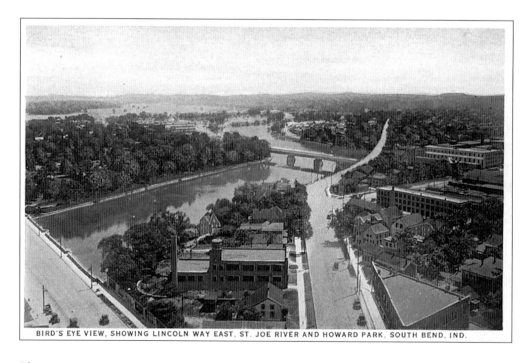

BIRD'S EYE VIEW, SHOWING LINCOLN WAY EAST, ST. JOE RIVER AND HOWARD PARK, SOUTH BEND, IND.

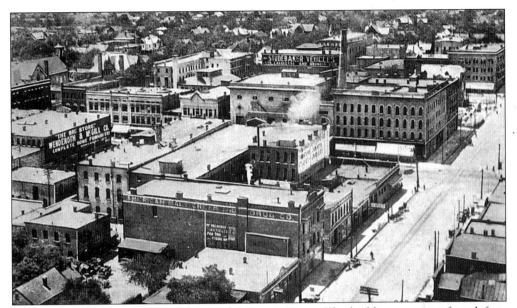

This view overlooks Michigan Street and Jefferson Street. The buildings running from left to right on Michigan, near the center of the card, housed several clients: the Merchants' National Bank, the F. W. Woolworth Company, South Bend and Mishawaka Gas Company, the Auditorium theater, and the former Studebaker Wagon Repository. The Auditorium was demolished in 1920 and the repository was demolished in 1975.

This aerial view of downtown shows the city at its zenith. In the lower left hand corner is Lafayette Street. The next road is Main Street, showing, from left to right, on the even-numbered side of the street: the Oliver Theater, the J. M. S. Building, Washington Street, the Odd Fellows Building, Renfranz-Rasmussen (clothing), Noisom Jewelers, City Barbecue, George Krislas, Main Coney Island (restaurant), Ault Camera Shop, the Conservative Life Building, Business Sysems, Inc., Mary-Helen Shop, Modern Cleaners and Laundry, and the Kimble Shop. Jefferson intersects at this point. The Federal Building and YMCA comprise the 200 block. Wayne Street intersects.

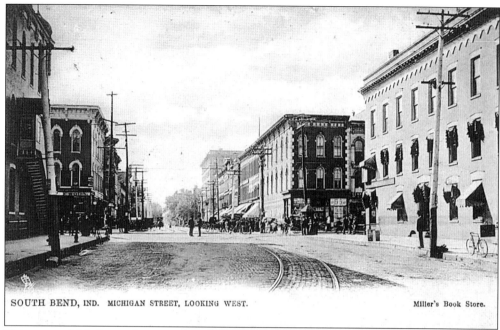

SOUTH BEND, IND. MICHIGAN STREET, LOOKING WEST. Miller's Book Store.

This view of Michigan Street is from the corner of Michigan Street as it looks onto West Washington Street. At the near left hand corner is the Sarantos and Kronteres Shoe Shine Parlor and Rooming House. On the near right hand side is the office for the Chicago, South Bend & Northern Indiana Railway Company and the Southern Michigan Railway Company. Near the center of the view is the American Trust Building.

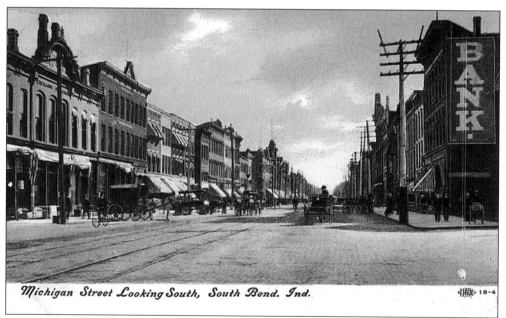

Michigan Street Looking South, South Bend. Ind. 18-4

The double set of street car tracks and the horse-drawn carriages show the busy 100 block of South Michigan Street looking south from Wayne Street. The number of small businesses on this block are too numerous to name.

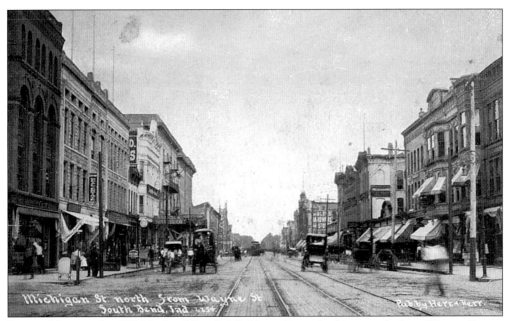

Pictured here is the 200 block of South Michigan Street looking north from Wayne Street. Some of the buildings in this 1909 postcard on the left are F. W. Woolworth's, the Auditorium, and Vernon Clothing Store. Some of the buildings on the right are the Central Storage Company, Slick Card Company, and Barnett's Market.

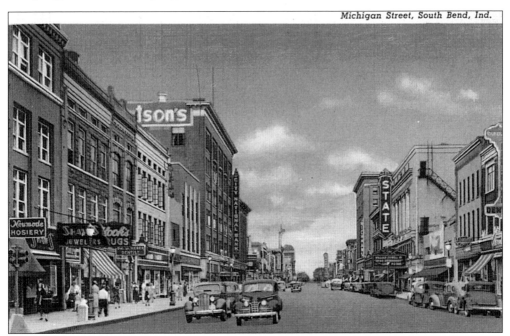

This image was taken looking north at the 200 Block of South Michigan Street from the corner of Wayne Street. How many buildings do you recognize from the postcard above? The Robertson's Department Store replaced the Auditorium and is now an apartment complex. The State Theater is now a popular nightclub. Some of the buildings in this 1940s postcard still remain.

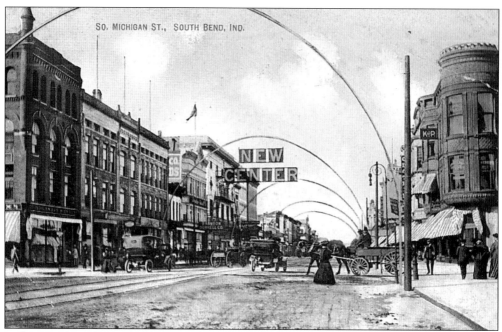

So. MICHIGAN ST., SOUTH BEND, IND.

In honor of South Bend's 1909 homecoming celebration, Michigan Street was named "New Center." The gala event drew thousands of former South Benders back to their home town. This is the 200 block of South Michigan Street looking north. You should recognize most of the buildings from previous postcards.

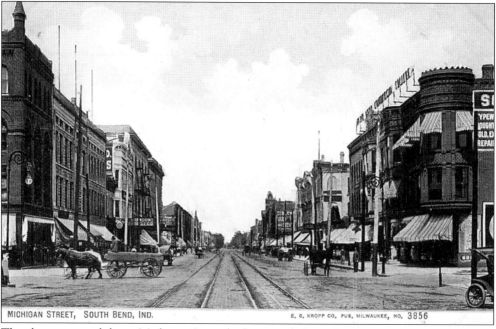

MICHIGAN STREET, SOUTH BEND, IND. E, C, KROPP CO, PUB, MILWAUKEE, NO. 3856

The above postcard shows Michigan Street looking south from Wayne Street again. This block has to be the most popular view of Michigan Street, judging by the large number of postcards that show this view.

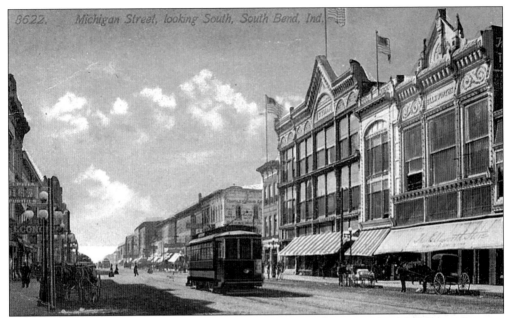

The South Bend Street Railway had street car routes on Washington, North Michigan, Portage, and Chapin Streets by 1885, when the city invited Charles Van Depoele to construct an electric trolley car system. Although initially successful, the electric trolleys had problems, and the city returned to horse-drawn trolleys in 1886. Electric street cars were successfully re-introduced in 1890. This 1909 postcard shows the 100 block of North Michigan Street on a rare quiet day. The street car is passing Wyman's Department Store. Next to Wyman's is the Ellsworth Store, their fiercest competitor in the dry-goods business; both went after "the carriage trade."

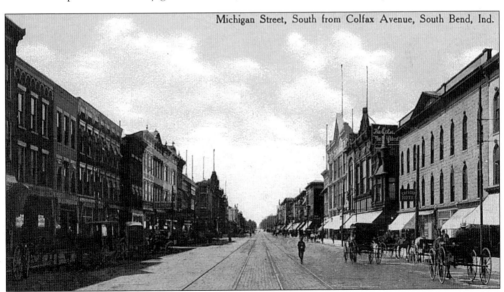

Michigan Street, South from Colfax Avenue, South Bend, Ind.

This postcard shows the 300 block of North Michigan Street looking south from Colfax Avenue. Buildings on the left side include several small doctors' offices, Samuel C. Lontz and Company, and the South Bend Supply Company. Buildings on the right side are the Masonic Lodge (with rooms for rent), Kline Electric Company, and the Hay and Gray Warehouse.

17

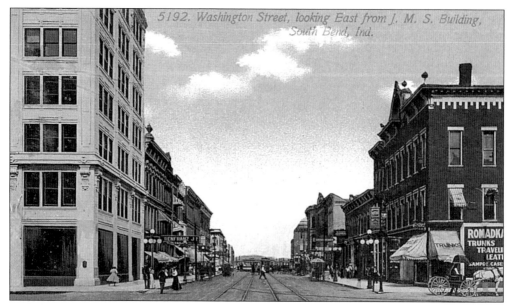

This 1911 postcard shows West Washington Street looking east from the J. M. S. Building at the intersection of Main Street. Buildings on the left side, from the nearest to the farthest buildings, are the J. M. S. Building, St. Joseph County Savings Bank, Del Mar Hotel, and the American Trust Building. Buildings on the right side, from the nearest to the farthest, are the Romadka Brothers, the Odd Fellows Building, Newark Shoes, and United Cigar Stores.

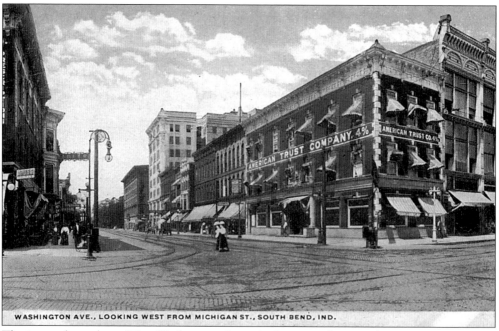

WASHINGTON AVE., LOOKING WEST FROM MICHIGAN ST., SOUTH BEND, IND.

The image above shows West Washington Street looking west from Michigan Street. All of the buildings on the left side of the street are now taken up by the Teacher's Credit Union Building and its parking lot. The American Trust Building and the J. M. S. Building (near the center of the postcard) are still standing. The names of the buildings are detailed above.

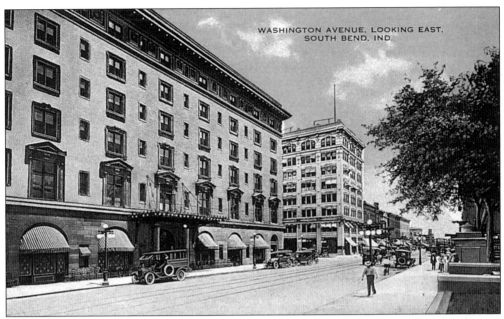

The Oliver Hotel dominated almost every postcard of the Washington Street business district.

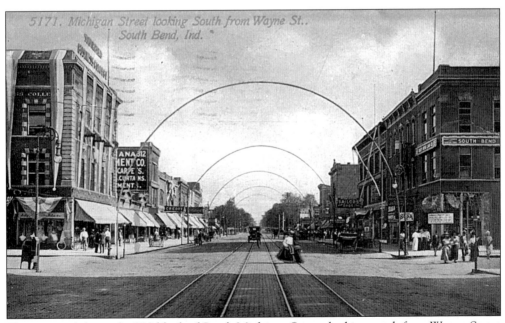

This postcard shows the 300 block of South Michigan Street, looking south from Wayne Street in 1909. Some of the buildings on the left side, from nearest to farthest, are the South Bend Business College, the People's Store, and the Indiana Theater. Among the buildings on the right side, from nearest to farthest, are the South Bend Loan Company, the Economical Drug Store, Howard Brown Company, and Sailors Brothers Company.

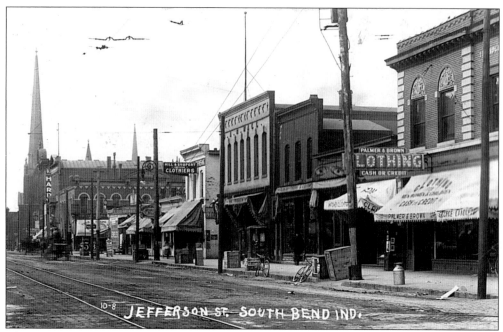

This 1908 postcard of the 100 block of East Jefferson Street shows, from left to right, Mike's 3C Restaurant, The Original Cut Rate Medicine Store, Steger Piano Store, United Coal Yards Company, Hill and Shupert Clothing, the G. A. R. Hall, City Loan Office, Electric Construction Company, the Building and Loan Association of South Bend, and the Palmer and Brown Clothing Store.

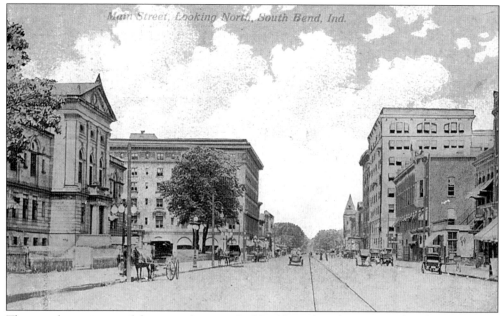

The courthouse is one of the most photographed buildings found on postcards. This card shows the courthouse, the Oliver Hotel, and the J. M. S. Building. At the far end of the street on the right hand side is the city hall.

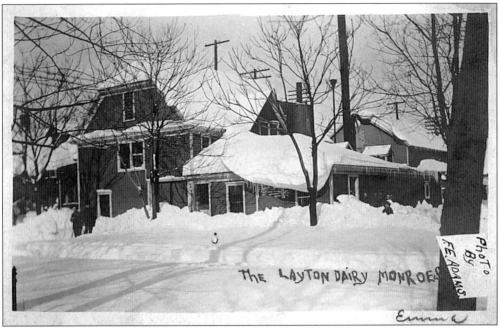

Charles H. and Dewey C. Layton started the Layton Dairy at 119 East Monroe Street shortly before 1900. By 1901, they had built up both a wholesale and retail dairy business, delivering to all parts of the city. Five wagons were kept in constant use. Charles had earlier been involved with a dairy in Clay Township before joining his brother. They later sold the dairy to the South Bend Sanitary Milk Company.

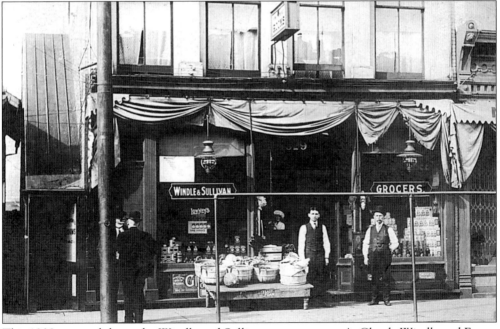

This 1908 postcard shows the Windle and Sullivan grocery store. A. Claude Windle and Ernest A. Sullivan started their store at 327 South Michigan Street. It only lasted a short time.

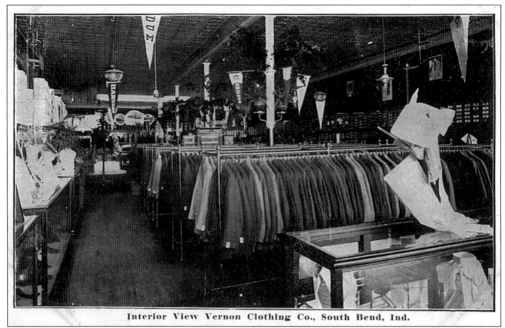

Interior View Vernon Clothing Co., South Bend, Ind.

Vernon Clothing Store occupied 205–207, and later 213–219, South Michigan Street from around 1906 to around 1925. It was on the first floor in the same building as the Auditorium Theater. Freeman Vernon (and later K. C. De Rhodes) ran this store for nearly 20 years. It was replaced by the Robertson's Department Store around 1925.

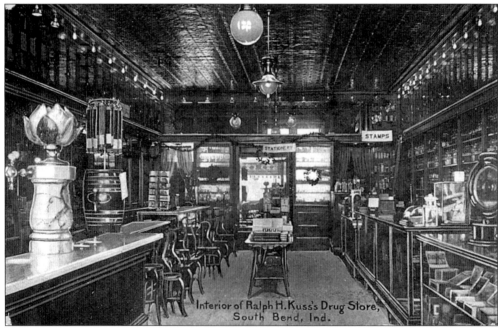

Interior of Ralph H. Kuss's Drug Store, South Bend, Ind.

Ralph H. Kuss opened his drug store in 1892 at the corner of South Michigan and Sample Streets and remained in business there for more than 40 years before retiring.

The highly successful South Bend Farmer's Market started out with a series of independent farmers selling their produce on the Market Street bridge overlooking the St. Joseph River. Later, Market Street was renamed Colfax Avenue. In 1924, the farmers organized the farmer's market and moved it to Sample Street, between Mishawaka Avenue and North Side Boulevard. A disastrous fire destroyed the original red wooden building, but it was quickly rebuilt. It still continues to be a major attraction on Tuesdays, Thursdays, and Saturdays.

The Yeager Motor Company at 305 South Lafayette Boulevard sold Buick automobiles. Freeman C. Yeager started the company around 1936 at 305 South Lafayette. The company later moved to 225 South Lafayette. It was replaced by the Gurley Leep Buick Opel dealership in 1977.

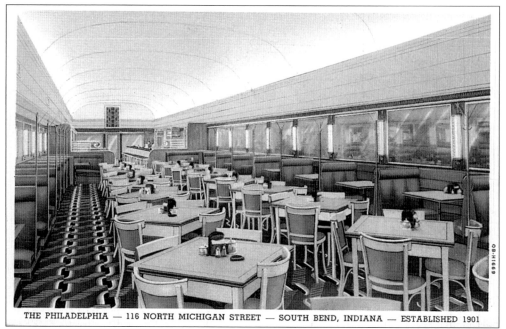

THE PHILADELPHIA — 116 NORTH MICHIGAN STREET — SOUTH BEND, INDIANA — ESTABLISHED 1901

Greek immigrants Eustice, Andrew, and Pendel Poledor established The Philadelphia in 1901. First a small confectionery and candy-making store, by the 1950s, the store had grown into a three-story ice cream shop where teenagers spent long hours over large sodas, ice cream, french fries, and hamburgers. It closed during urban renewal.

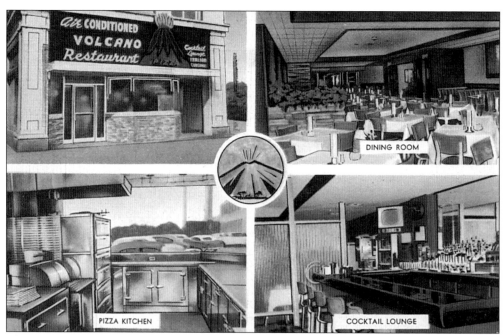

The Volcano Restaurant and Lounge at 219 North Michigan Street specialized in fine Italian and American cuisine. The back of this postcard says that it was "acclaimed by Collier's Magazine as one of the finest Pizzerias in the United States." It closed during urban renewal.

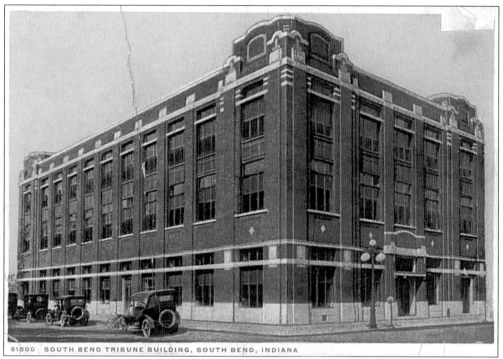

81500 SOUTH BEND TRIBUNE BUILDING, SOUTH BEND, INDIANA

The *South Bend Tribune* printed its first issue on March 9, 1872, and has continued to publish the city's largest newspaper ever since. In addition to printing the newspaper, the company also published some early St. Joseph County history books and postcards and had a small stationery store. The *Tribune* moved into this new building on April 25, 1921. The building had an auditorium seating 500 people.

NOTICE

Your **South Bend Tribune** Travel Accident Policy,

No. *512 & 969* will expire *11-22-28*.

Either mail or bring in this card with remittance of $1.00 to the Circulation Department of the South Bend Tribune. Do not delay and let your policy lapse.

The South Bend Tribune

Always looking for new ways to increase their income, during the 1920s, the *South Bend Tribune* also issued travel insurance policies and regularly sent out postcards to remind their customers that policies were due for renewal.

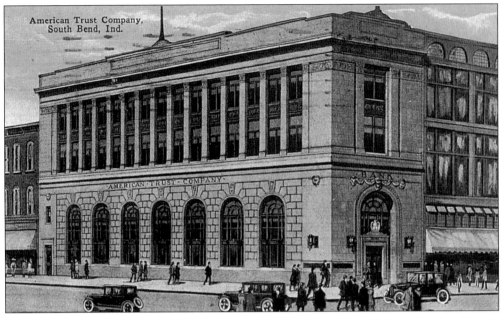

The American Trust Company began business in 1904 at the northwest corner of Washington Avenue and Michigan Street. By 1922, it had expanded enough to need a new building. The four-story building was constructed in 1922 and 1923. The first floor was 26 feet high and contained 21 tellers' cages. The interior was finished in marble. The round door for the deposit box weighed 38,700 pounds and the rectangular bank vault door weighed 19,700 pounds.

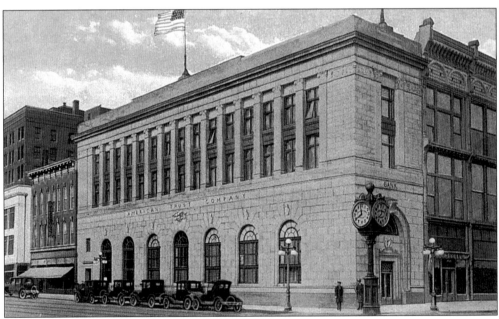

The large, four-sided clock was erected on the corner of Washington and Michigan Streets in 1913. It remained long after the American Trust Bank moved to new headquarters but was removed during urban renewal. When the Marriot Hotel was built, the clock was moved to the atrium between the hotel and First Source Bank. It was restored in 1985 by Southold Restorations.

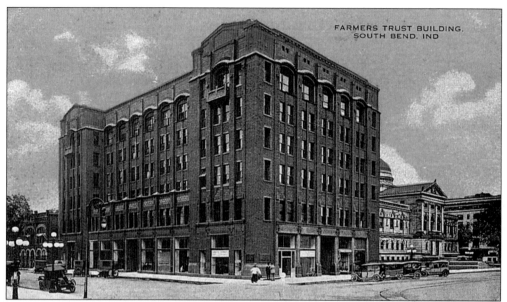

The six-story Farmer's State Bank at 133 South Main Street was erected in 1915, replacing the First Methodist Episcopal Church which formerly stood here. It later became the headquarters for the Associates Investment Company and then the First Bank and Trust Company. Like most buildings of the day, it had an elevator with an operator. Long after most office building elevators had gone self-service, you could still count on finding an elevator operator here.

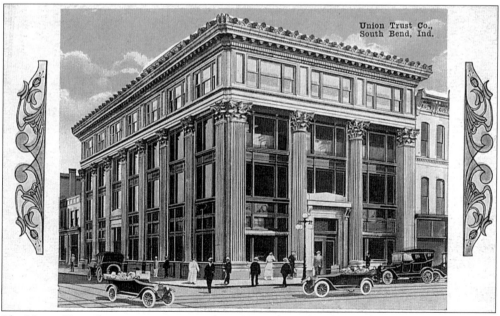

Union Trust Co.,
South Bend, Ind.

The Union Trust Company was organized in 1908 and stood at the southeast corner of Michigan and Jefferson Streets. In 1922, it became affiliated with the First National Bank. The building was enlarged to accommodate the First National Bank. The bank specialized in commercial banking, while Union Trust Company continued as a savings bank, paying interest and making mortgage loans. The bank was torn down during urban renewal.

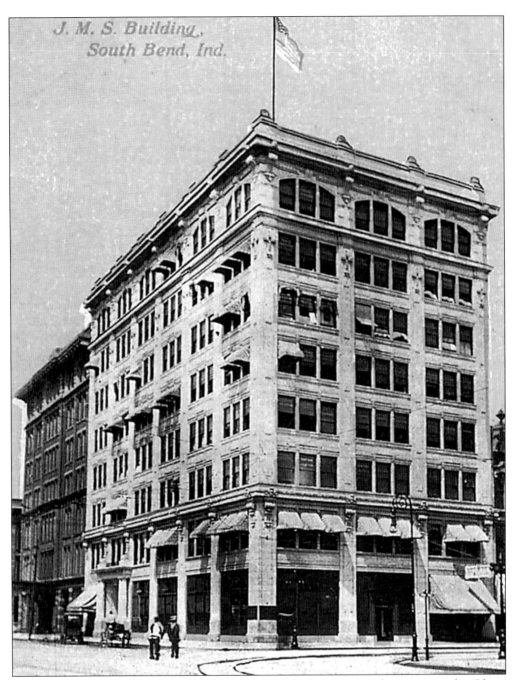

J. M. S. Building,
South Bend, Ind.

Not to be outdone by the elaborate Oliver Hotel, which sat across the street, or the Oliver Opera House/Theater, which stood next to this building, John Mohler Studebaker constructed the imposing eight-story, terra cotta J. M. S. Building in 1909 and 1910. Luckily, Oliver and Studebaker were friendly rivals. The top cornice of the J. M. S. building hung about five feet over into the Oliver Theater property line, but this didn't stop Oliver from adding three more floors to his Theater. The Oliver Hotel and Theater are gone, but the J. M. S. Building stands proud and is still an important office building.

Two
HOTELS

The first "hotel" was established as a tavern by Benjamin Coquillard shortly after he arrived in the small village. By 1930, there were 30 hotels in South Bend, ranging from the cheapest, catering to bums and the poor; through hotels established for ethnic groups; to the Oliver Hotel, considered the most luxurious accommodation in the city. Seven of the hotels were considered "first class" and together offered a total of 1,050 rooms. Wanting to show the city in its best light, very few postcards covered any hotel except the Oliver, the Hotel La Salle, and the Hoffman.

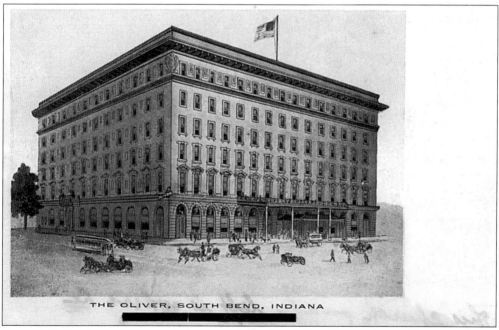

THE OLIVER, SOUTH BEND, INDIANA

Not satisfied with the accommodations at existing South Bend hotels, James Oliver decided to construct his own hotel, wanting to create the best first-class hotel outside of Chicago. He boasted of its fireproof construction of concrete, brick, and steel. When the Oliver Hotel was opened to the public on December 21, 1899, the *South Bend Tribune* called it "the best and most magnificent hotel in Indiana, one of the finest in the United States, and the best in any city of 40,000 inhabitants in the world."

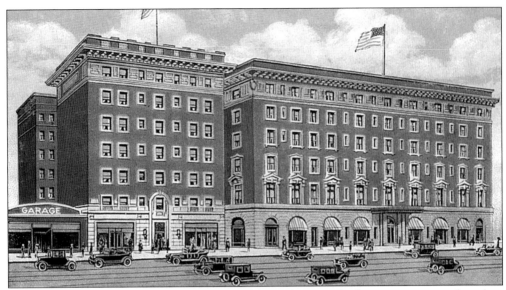

The basement rivaled the lobby for beauty and housed a steam bath, a swimming pool, and an athletic area. In 1906, the charge for using the baths was 25 cents. (During winter afternoons the charge was only 15 cents for boys and young men who brought their own towels.) Nearby were the electric baths, where an experienced operator stood on metal plates and allowed a light current of electricity to pass through his body first. Then the electric vibrator was applied for a complete magnetic treatment. After using the steam baths and electric vibrator, patrons could cool down on one of the many iron beds. As many as 60 to 100 men were able to use the facilities each night. All of the services were for men only. Services for women were discontinued "some time ago."

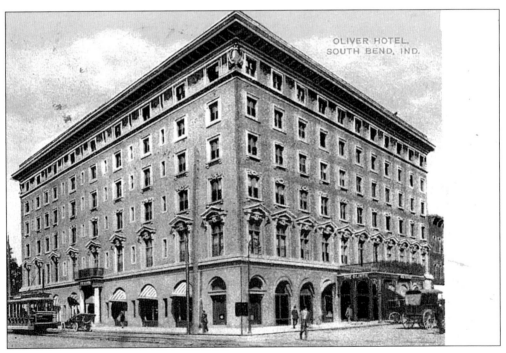

OLIVER HOTEL, SOUTH BEND, IND.

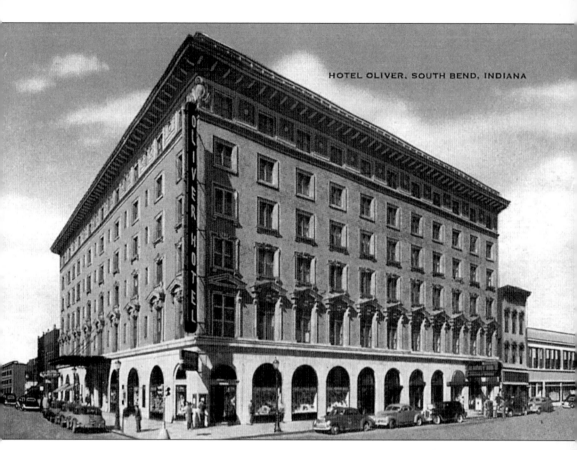

HOTEL OLIVER, SOUTH BEND, INDIANA

Unfortunately, the Oliver, like most hotels of its time, had discrimination policies. It refused a room to famous black opera star, Marian Anderson, who was in South Bend for at concert at St. Mary's College. Years earlier, it had refused a room to a traveling black college athlete, even though the entire rest of the team could stay because they were white. One white youth was incensed by the discrimination and offered to share his room with the black athlete. He vowed to change discrimination if he could. His name was Branch Rickey. Years later, as baseball commissioner, Rickey claimed that this incident led him to integrate professional baseball.

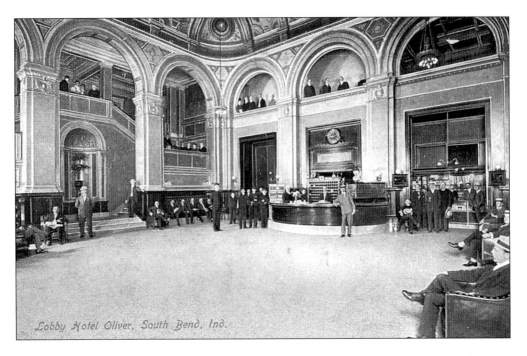

Lobby Hotel Oliver, South Bend, Ind.

These two views of the lobby (the top one from 1908 and the lower one from 1935), still reflect the mood first mentioned in the *South Bend Tribune* in 1899: "The interior decorations are almost beyond the expressive power of language. To attempt to convey with feeble words the real beauty and artistic conception of the paintings that adorn the wall of the hotel would be preposterous. They are too gorgeous and too beautiful to be imagined."

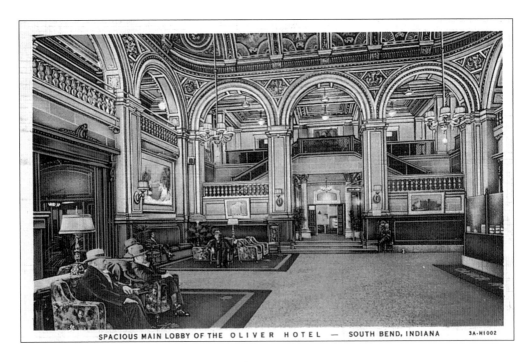

SPACIOUS MAIN LOBBY OF THE OLIVER HOTEL — SOUTH BEND, INDIANA 3A-H1002

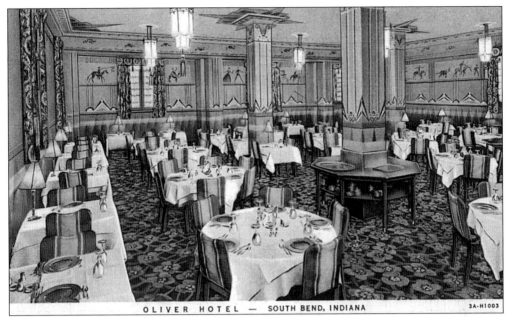

OLIVER HOTEL — SOUTH BEND, INDIANA 3A-H1003

The Oliver main dining room boasted up-to-date furnishings. Plates and silverware all bore "The Oliver" mark. One former worker recalls that during the Notre Dame football season, the crowds trying to get into the dining room were so large that hotel personnel had to set up ropes to control the situation.

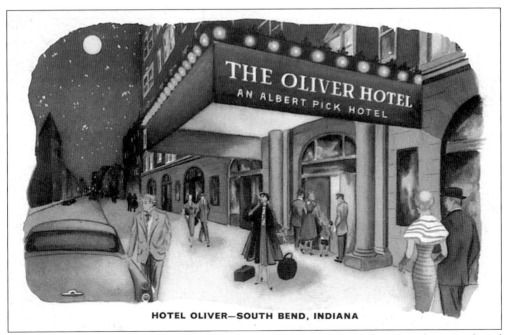

HOTEL OLIVER—SOUTH BEND, INDIANA

Abe Frank and Leo Strauss owned the hotel from 1914 to 1920. Andrew Weisburg purchased it, but sold it to Albert Pick in 1937. Pick renovated the hotel with a $100,000 reconstruction project. On May 1, 1967, Pick closed the hotel, tore it down, and built a 13-story hotel and office building. After several changes in ownership, the Holiday Inn opened here in 1987.

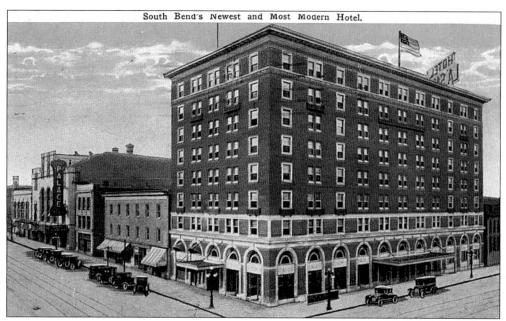

Not to be outdone, the Hotel La Salle was constructed in 1921 and showed the same attention to detail as its rival, the Oliver. Built directly across from the Chicago, South Shore & South Bend Railroad Station, the Hotel La Salle contained 300 rooms and was one of the most elaborate hotels of its time. It catered to large crowds coming into town for Notre Dame football games. A tunnel ran between the hotel and the South Shore Station so that passengers would remain dry. The hotel is still in largely original condition and may soon house upscale apartments.

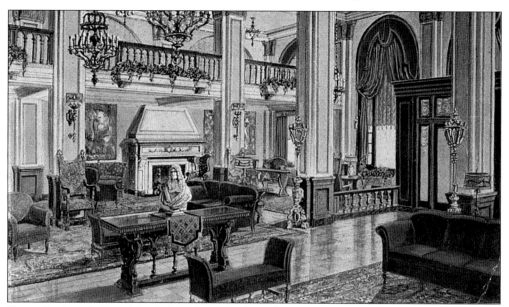

Knute Rockne died on March 31, 1931. His funeral was on the following Saturday. It was the largest funeral in South Bend, and thousands of people lined the streets to view the funeral procession. For those who could not find space in line, the La Salle Hotel lobby offered space for hundreds of people to listen to the funeral as it was broadcast over WSBT radio.

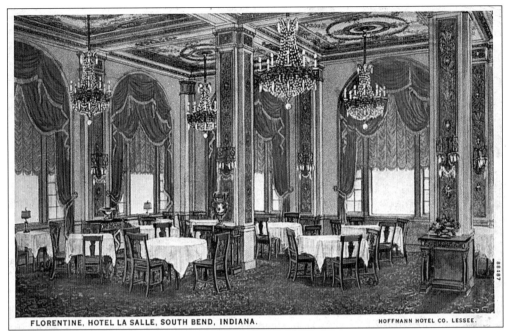

This 1929 view of the main dining room (the Florentine Room) evidences the designer's desire to compete with the Oliver. The dining room still retains much of its original beauty. In addition, there was a College Inn and a Coffee Shop.

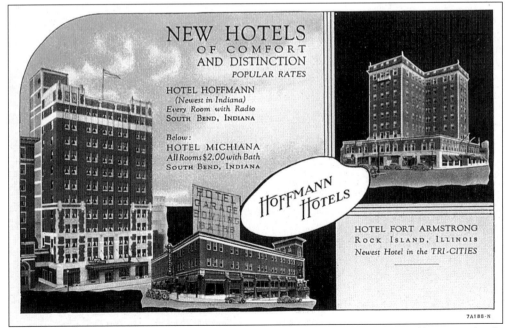

The Hoffman Hotel was completed in 1930 and offered 150 rooms, as well as completely furnished apartments, a grill, and a cocktail lounge. It also advertised that it had a radio in every room. The hotel is now an office complex.

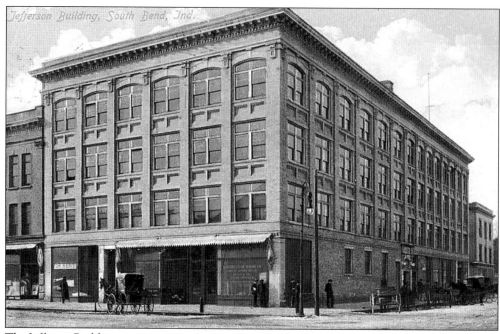

The Jefferson Building was constructed in 1903 at 201–203 South Main Street as an office building.

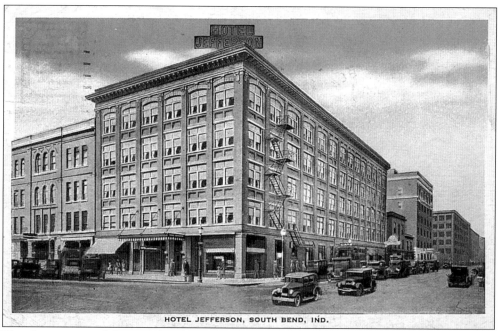

HOTEL JEFFERSON, SOUTH BEND, IND.

The desperate need for new hotels to accommodate South Bend's growing population and increasing visitors caused the Jefferson Building's owners to add a fourth floor and convert the building to a modern hotel. In 1920, it boasted 125 rooms and a café. By 1930, it had 150 rooms and a café. The hotel closed around 1952, and the building was taken over by the South Bend Federal Savings and Loan Association. The building was demolished in 1980.

Three
GOVERNMENT
BUILDINGS

The first post office was established in Lathrop Taylor's trading post. The first court cases were heard in Benjamin Coquillard's tavern. An adequate fire department and sewer system did not yet exist in the 1830s. By 1930, though, South Bend had already been in its new city hall for two decades, court trials were being held in the third courthouse, and the post office was considering construction of its third building in less that fifty years. The fire department employed 122 men, with 3 autos, 7 engines, 4 hose wagons, 1 chemical wagon, and 3 hook-and-ladder trucks, in 10 stations.

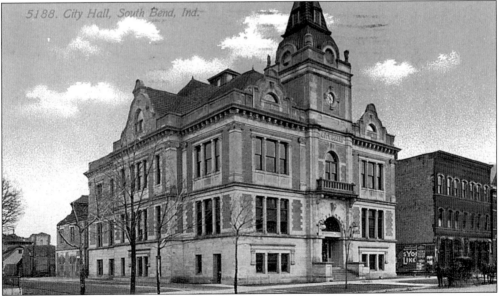

At the turn of the 20th century, South Bend's population had expanded beyond the means of the city to serve its citizens, and a new city hall was needed. But South Bend was already financially strapped, so James Oliver stepped forward and paid for the construction of this imposing structure at 214–218 North Main Street. The hall was built in 1901 and demolished in 1970.

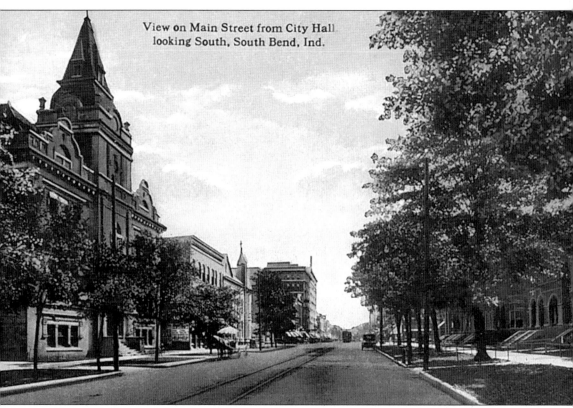

View on Main Street from City Hall looking South, South Bend, Ind.

The city hall was on the edge of the city's business district. Just north of the city hall, on both sides of the street, private houses were slowly giving way to churches. Just across the street from the city hall (barely seen in this postcard) was Oliver Row, an apartment complex which was built by James Oliver for his son, Joseph, and his son's new bride, Anna. Joseph and Anna occupied Apartment Number One.

(*opposite*) The 1854 courthouse was originally built on Main Street facing east. Among the important events which have occurred on its steps are the declaration of the Civil War, and Schuyler Colfax's impassioned speech declaring that he was innocent of the charges laid against him in the Credit Mobilier Scandal. Colfax died in 1885. The public viewing was in the courthouse. In 1896, the 1854 courthouse was re-oriented 180 degrees to make room for the third courthouse, which was finished in 1898—it now rests on Lafayette Street, directly behind the 1898 courthouse. Used for many decades by the Northern Indiana Historical Society, it almost met the wrecking ball during the urban renewal of the 1960s. In the early days, a large public fountain stood in the northeast corner of the courthouse yard. It was to the right of the main entrance as one faced the building. The fountain disappeared around the turn of the 20th century. Today, the courthouse is a national historical landmark and is again a working courthouse.

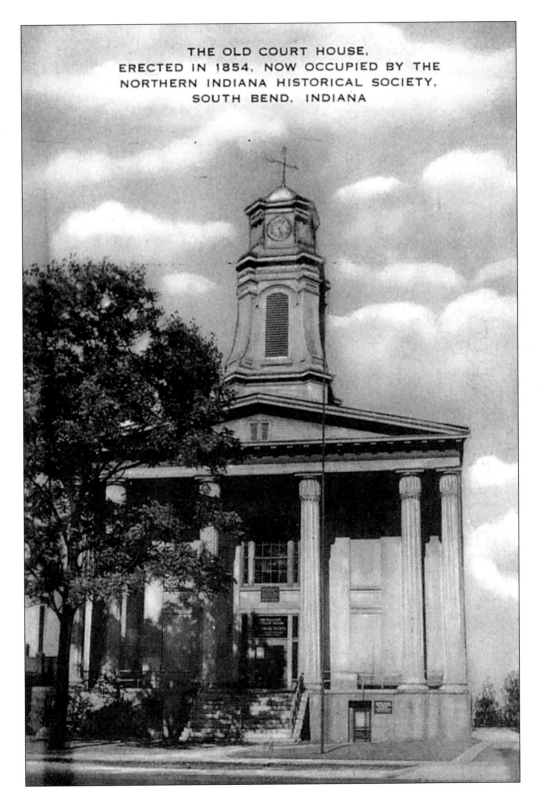

THE OLD COURT HOUSE,
ERECTED IN 1854, NOW OCCUPIED BY THE
NORTHERN INDIANA HISTORICAL SOCIETY,
SOUTH BEND, INDIANA

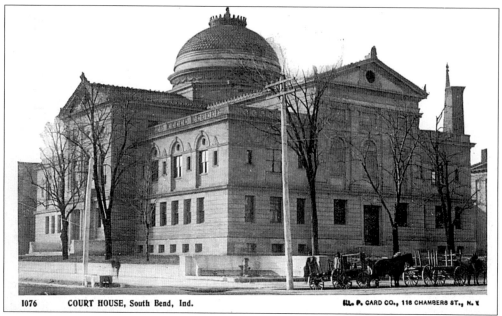

1076 COURT HOUSE, South Bend, Ind. ILL. P. CARD CO., 118 CHAMBERS ST., N. Y.

On October 31, 1896, the county contracted for its third courthouse. The original contract was for $184,241.27. However, by the time changes were made, the cost had spiraled to almost $250,000. The cornerstone for the third St. Joseph County Courthouse was laid on April 15, 1897, and the building was completed on November 4, 1898, on the grounds of the 1854 structure.

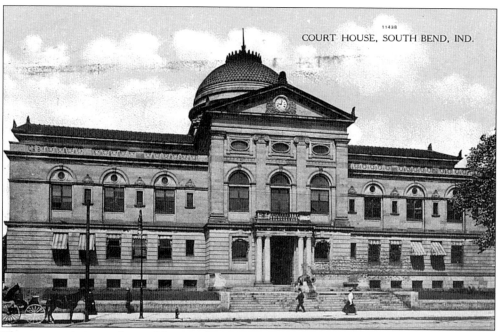

11438
COURT HOUSE, SOUTH BEND, IND.

The cannon sitting in front of the courthouse was captured in the Battle of Santiago during the Spanish American War and presented to the city in 1899 by Representative Abraham L. Brick, who was Indiana's representative from the 13th Congressional District. On October 4, 1942, the cannon was sent to the scrap metal drive to be melted down for vital military needs.

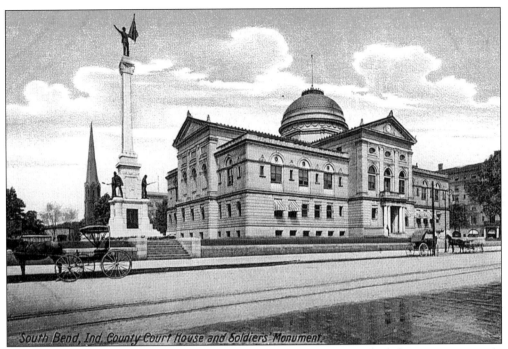

South Bend, Ind. County Court House and Soldiers' Monument.

Shortly after the courthouse was constructed, patriotic citizens asked for a monument to commemorate the participation of St. Joseph County's soldiers and sailors in the Civil War and Spanish American War. Many hoped that it would be put in the newly developed Howard Park. However, the monument was constructed on the south side of the courthouse.

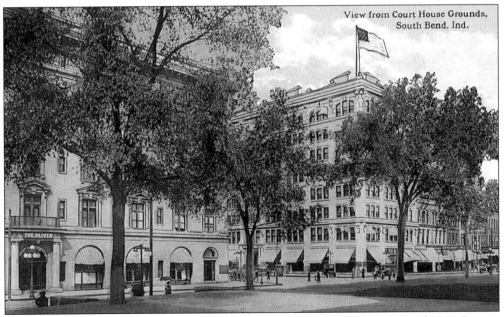

View from Court House Grounds, South Bend. Ind.

In the early 1900s, the busiest intersection in South Bend was at Washington and Main Streets. The Oliver Hotel, the new J. M. S. Building, and the courthouse all brought politicians, visitors, and businessmen to the heart of the city. Today, things have changed very little.

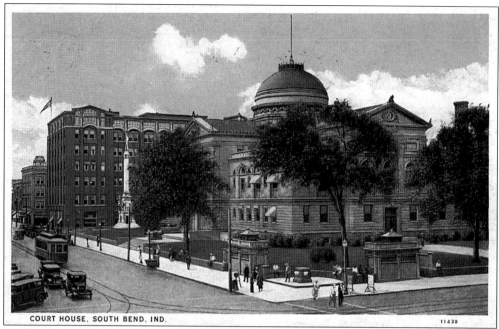

COURT HOUSE, SOUTH BEND, IND. 11438

By the late 1920s, "comfort stations" were added to the courthouse lawn for public use. They remained in use until the 1960s, when loiterers used them inappropriately and it was necessary to remove the stations.

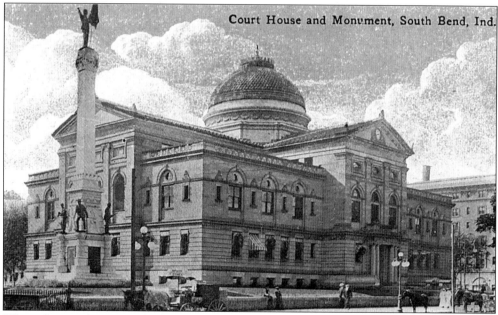

Court House and Monument, South Bend, Ind.

When the courthouse was built, citizens complained that it was too large and the city would never need all of the space. By the 1950s, quarters were tight, and in 1967, a new county city building was erected. Today, the county city building, the 1898 courthouse, and the 1854 courthouse are all used for county activities.

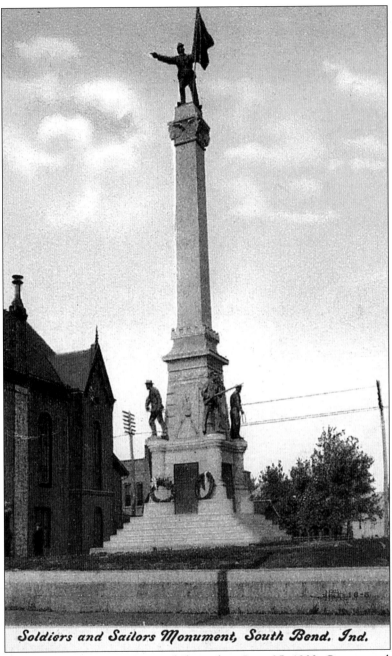

Soldiers and Sailors Monument, South Bend. Ind.

The Soldiers and Sailors Monument was dedicated on June 25, 1903. Constructed of granite and bronze, it was intended to honor the heroic soldiers of every war since the American Revolution who are buried in St. Joseph County. The heroic Civil War figure surmounting the shaft holds the Union colors and confidently cheers his fellow soldiers onward to victory. When the monument was first erected on the south end of the court yard, the Color Bearer on top pointed to the south and led his valiant troops against the enemy. The monument was disassembled in the 1970s during urban renewal, and when it was later re-constructed, the monument pointed northward. This is still a sore point for historical purists.

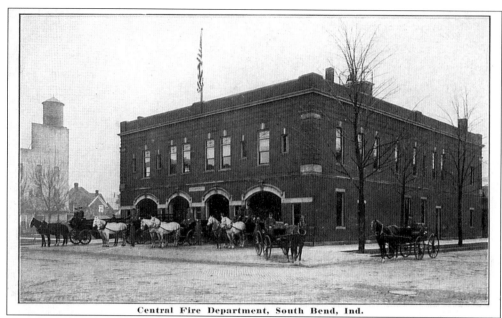

Central Fire Department, South Bend, Ind.

The Central Fire Station and fire chief's headquarters were located at 202–206 East Wayne Street. In 1914, Irving W. Sibrel was chief; William Smith, assistant chief; and Chester Van Arsdel, houseman. The station also housed Truck Company No. 1, Truck Company No. 2, Chemical Engine No. 1 (Auto,) and Hose Company No. 1. It was abandoned in 1967.

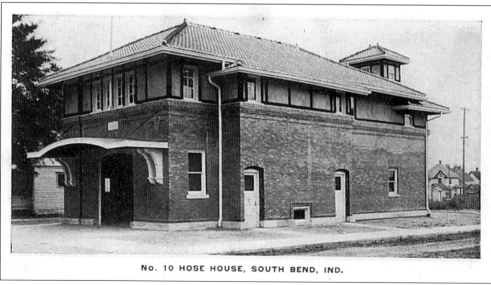

NO. 10 HOSE HOUSE, SOUTH BEND, IND.

Hose Company No. 10 was located at 1824 South Michigan Street. In 1914, August Hoglund was captain; William Heilman, lieutenant; Alfred Lentz, pipeman; John Schroth, pipeman; and Arthur Peterson, driver.

44

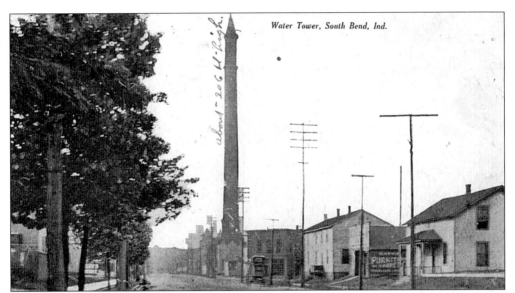

Water Tower, South Bend, Ind.

In 1871, city officials felt that the current water works and fire protection system were inadequate. Three different water systems were proposed and a spirited war broke out between the advocates of each system. By 1872, a decision was made to use the stand pipe system, in which water was stored in a tower and the pressure from the water filled the water mains at a constant pressure throughout the city. The standpipe was raised on November 15, 1873. The wrought-iron pipe was 200 feet high; it was set up on the north side of Pearl Street, not far from the intersection of the first alley west of Carroll Street. John Studebaker was skeptical that the system, being so far from his factory, would be able to protect it in case of a fire. His skepticism was short lived when, on a bet, he stood in the belfry of the Studebaker Wagon Works, and a one-inch stream of water roared from the hydrants and rose past the top of the belfry. The standpipe stood in good service for nearly 60 years before being razed on July 29, 1930. The standpipe provided major fire protection until a series of pumping stations were built. The North Pumping Station was built in Leeper Park in 1895. It was re-built in 1914.

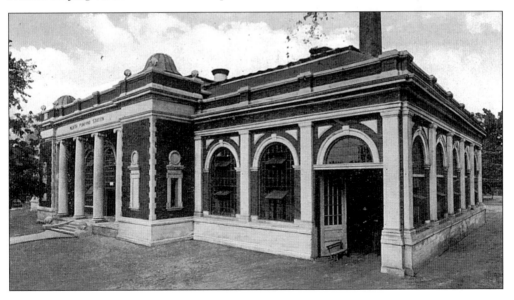

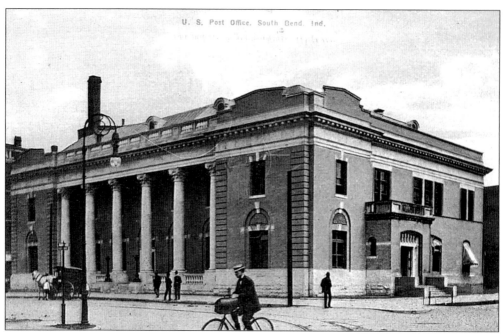

South Bend's first post office was established in 1829. The first Federal Building, including the post office, was constructed at the southeast corner of Main and Jefferson Streets in 1898 for $75,000. Already inadequate when it was finished, it was elaborately reconstructed in 1908 for $66,300.

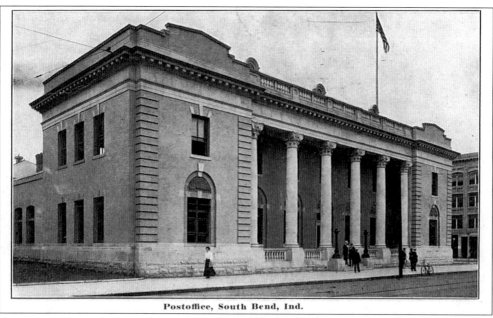

Postoffice, South Bend, Ind.

An increasing population and a newly established Federal Court in South Bend made the 1908 building completely inadequate. It was razed in 1931.

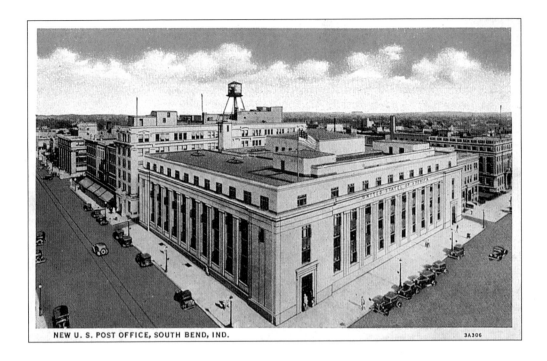

NEW U. S. POST OFFICE, SOUTH BEND, IND. 3A306

This new Federal Building was erected in 1931 and 1932. It opened its doors on March 13, 1933. The exterior work of the building, which covered a ground area of about 27,800 square feet, required 50 carloads of Indiana limestone, more than 10,000 barrels of cement, and 1,000 tons of structural steel.

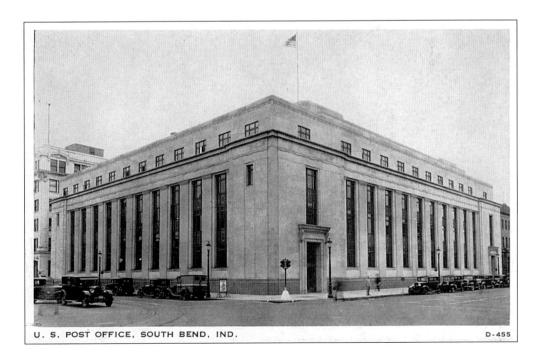

U. S. POST OFFICE, SOUTH BEND, IND. D-455

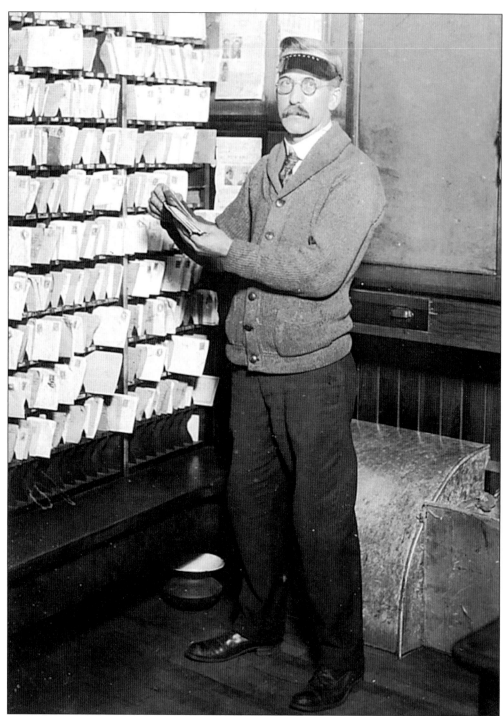

John Shirk worked as a postal clerk for the post office for more than 30 years and saw many changes in mail delivery during his employment. He received his appointment in the post office on September 15, 1906, spent several years as a carrier, and for 18 years served at the general delivery window in the post office. He retired on November 31, 1937.

Four
SOCIAL ORGANIZATIONS

Social organizations such as the Masons were organized early in South Bend. By 1930, there were 41 clubs and organizations offering a wide variety of activities to the working class as well as the business owner. Some organizations built impressive "skyscrapers," while others still remained in one- and two-story buildings. Both the YMCA and the YWCA were highly popular with teens and adults. Increasing membership often created a strain on the existing facilities and new buildings were needed.

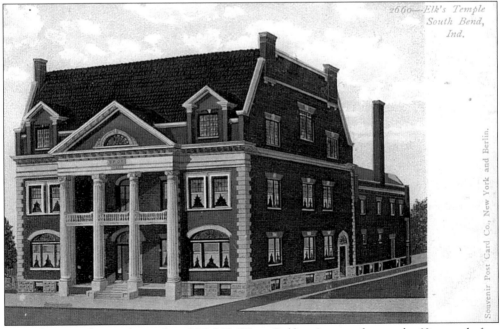

The Elks Temple was located at 217–219 West Colfax Avenue for nearly 60 years before moving to new headquarters on McKinley Avenue.

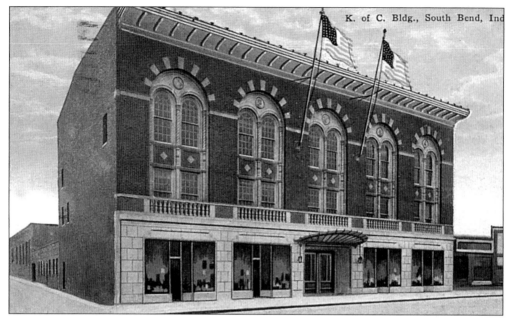

The Knights of Columbus built this magnificent building in 1924 at 320 West Jefferson. Financial difficulties later caused the Knights to sell their building. It then became the Indiana Club, which was a popular attraction for many years. Later, the Indiana Club also had financial difficulties, and it was feared that the beautiful building would be torn down. It faced some difficult days but is now the headquarters for H & G Services.

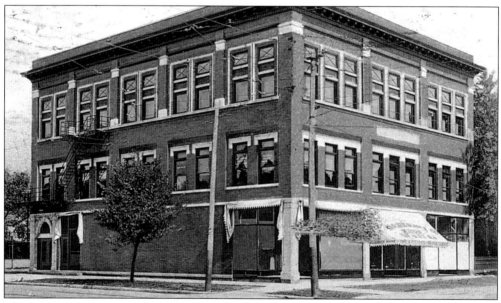

This Masonic Temple was located at 301–303 North Michigan Street. Construction began on a new temple at the corner of Main and Marion in 1922 and was finished in 1924. It was designed to house all of the Masonic chapters in South Bend. The North Michigan location was then demolished, and the Chicago, South Shore & South Bend Railway terminal was constructed on this site.

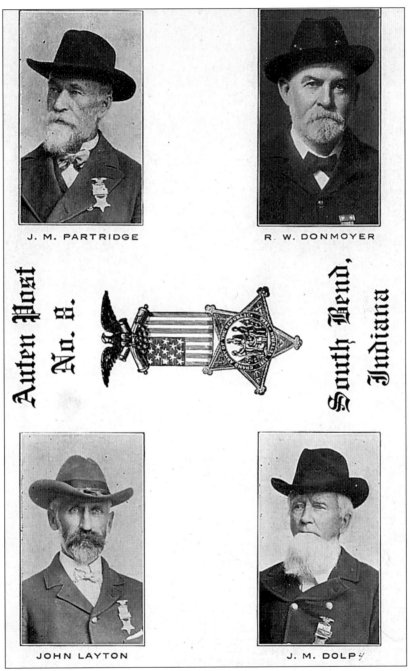

J. M. PARTRIDGE

R. W. DONMOYER

Auten Post No. 8.

South Bend, Indiana

JOHN LAYTON

J. M. DOLPY

Auten Post No. 8 of the Grand Army of the Republic was organized on August 31, 1866. It was named on honor of John Auten, the first Civil War soldier from St. Joseph County to be killed in the war. Composed of former Union soldiers, the post was both a social and a political organization. For many years, it was the only G. A. R. post in Northern Indiana. It had the great distinction of having been in continuous existence since its inception, never missing a meeting or election until its final members died and it was disbanded. It met regularly at the old 1854 courthouse.

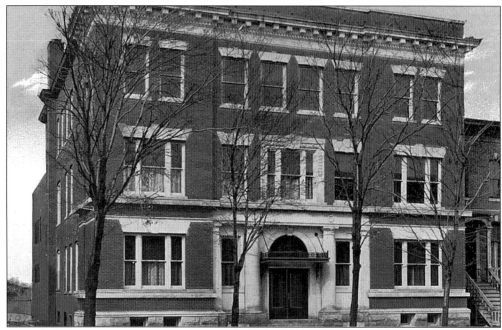

George and Clara L. Wyman donated $75,000 for the 1906 construction of the first Young Women's Christian Association building, located at 121 North Lafayette Street. Its cafeteria and tea room were open to the public. It had a well-equipped gymnasium and taught practical subjects in the evening school. Membership cost one dollar per year in 1914.

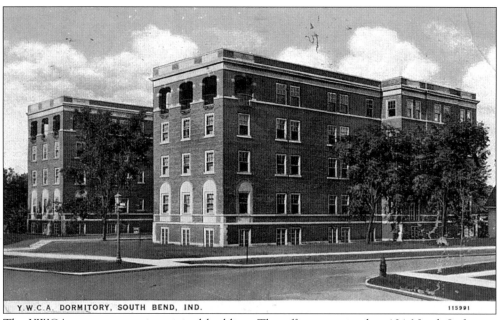

Y.W.C.A. DORMITORY, SOUTH BEND, IND. 115991

The YWCA soon outgrew its original building. The offices remained at 121 North Lafayette Street, even after a residential building was constructed at 802 North Lafayette Street. In 1962, the "Y" eventually consolidated their services at the residential address and remained there until 2002, when a new building was constructed on Fellows Street.

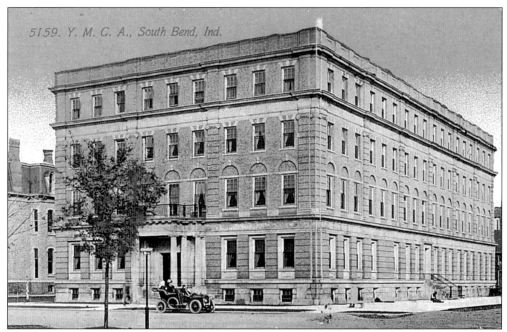

5159. Y. M. C. A., South Bend, Ind.

By 1902, the Young Men's Christian Association had outgrown its second building at 122–124 South Main street, with nearly 700 members actively using its facilities. The Studebaker Brothers Manufacturing Company donated $250,000 for construction of a new building at the corner of Wayne and Main Streets, across from the public library. The new building was dedicated in 1908. It included game rooms, a cafeteria, and a coffee shop.

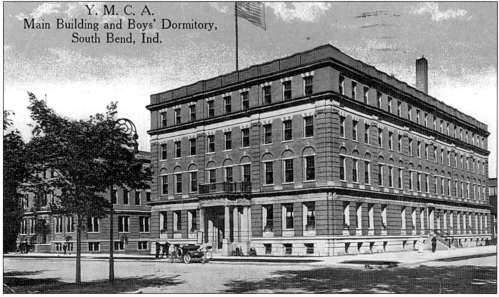

Y. M. C. A.
Main Building and Boys' Dormitory,
South Bend, Ind.

By 1908, the YMCA was feeling growing pains. In 1911, a three-story boy's building was added to the existing building. In 1913, a second addition was added, containing a boys' gymnasium, and 145 dormitory rooms, rented by the day, week, or month; its restaurant was open to the public. The "Y" remained here until it moved to 1201 Northside Boulevard in 1963.

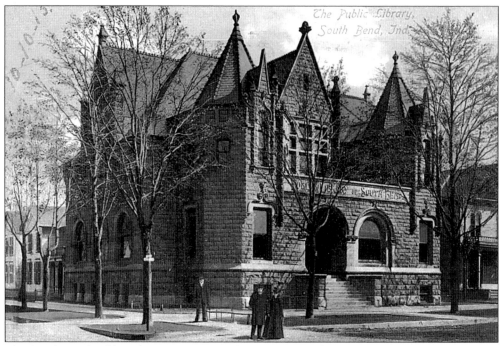

The South Bend Public Library was organized in 1873, but did not have a building of its own for many years. When the Oliver Opera House was constructed, the library occupied the fourth floor until this building was constructed in 1896 at the southeast corner of Main and Wayne Streets. Although considered to be a first-class library for its time, those who worked in it complained that it was drafty and cold. The basement was bare dirt. Many librarians called it "The Castle." Some were afraid to go into the basement because of "the critters."

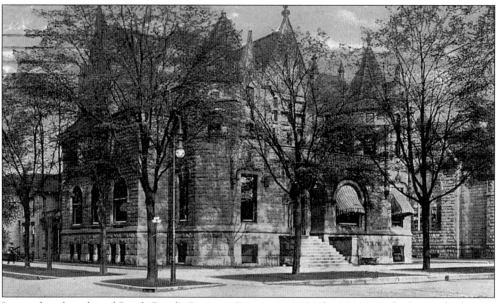

Located at the edge of South Bend's Business District in 1896, by 1910, nearby homes had given way to business. The stone building to the right of the library is the First Christian Church.

Five
HOSPITALS

Dr. Jacob Hardman arrived in the tiny village of South Bend in 1831, ready to serve the medical needs of 166 people. By 1930, there were 140 physicians and surgeons in South Bend, serving 110,000 people. Tough pioneers had their own medical remedies and seldom visited doctors unless it was absolutely necessary. It was over 50 years before South Bend had a hospital. In 1930, there were two hospitals, with 275 beds.

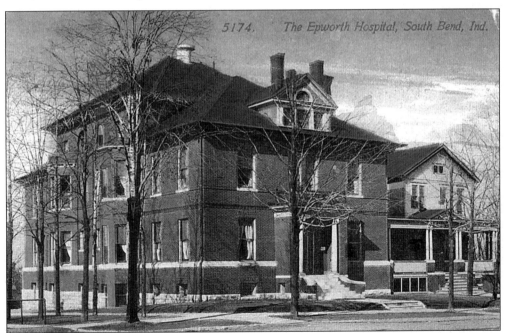

5174. The Epworth Hospital, South Bend, Ind.

Epworth Hospital started in the spring of 1893 when the Woman's Home Missionary Society of the First Methodist Church rented a building at the corner of Main and Navarre Streets to house "unfortunate" girls. Shortly after its inception, the home was turned into a hospital with three beds. By 1895, the home had progressed to 7 beds, and by 1945, the hospital had 40 beds.

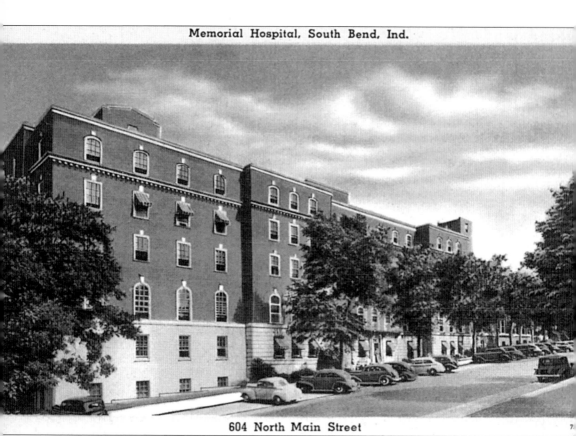

604 North Main Street

Epworth Hospital soon outgrew its original building and mission, evolving into Memorial Hospital. Today it continues to expand; it now covers several square city blocks.

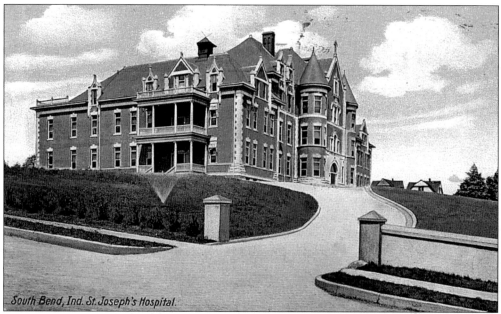

South Bend, Ind. St. Joseph's Hospital.

After the first St. Joseph's Church burned down in 1873, Father Sorin of Notre Dame erected a new, red-brick church at a different location. By 1880, he realized that the location of the church was poor. In addition, a new pastor at St. Joseph's Church wanted to return to the original church site. Stuck with the property, Sorin asked the nuns from St. Mary's Academy to set up a hospital. St. Joseph's Hospital was the first hospital to be erected in South Bend. The nuns were already experienced in nursing, having served as nurses during the American Civil War. Upon the hospital's grand opening in 1882, the *South Bend Tribune* wrote an article describing the hospital and urging every working man in town to contribute something each month to keep up the great services offered by the hospital. South Bend's growing population soon required that St. Joseph expand, and the cornerstone for a new St. Joseph's Hospital was laid on April 26, 1903.

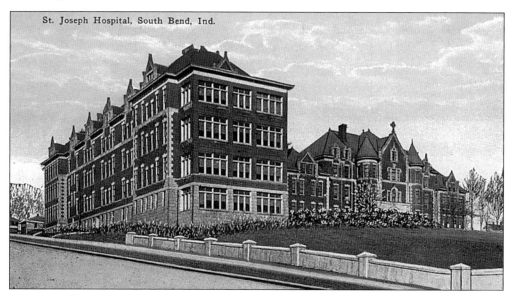

St. Joseph Hospital, South Bend, Ind.

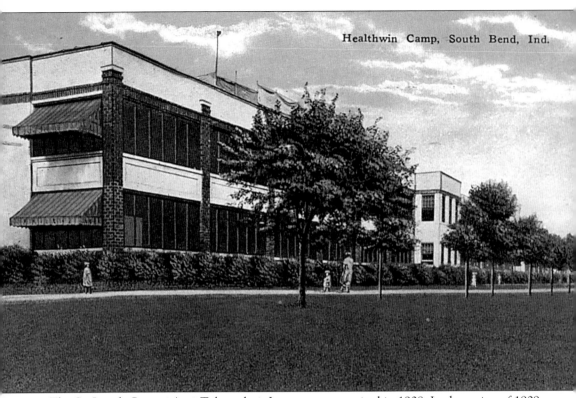

The St. Joseph County Anti-Tuberculosis League was organized in 1908. In the spring of 1909, the Indiana State Red Cross Society gave the League $325 for the erection of 4 cottages in Potawatomi Park. In July 1909, the camp was started with Dr. W. H. Baker in charge. The prevalent idea at the time was that the outdoors, even in the middle of winter, was good for curing tuberculosis. In 1912, the county commissioners and county council appropriated $15,000 toward the erection of a tuberculosis sanitorium, and in April 1914, Healthwin Sanitorium was established as an permanent indoor facility on Darden Road near the St. Joseph River.

Six
FACTORIES

The first factory established in South Bend was for the manufacture of glass. It was not a success. Within a few years, South Bend had learned how to harness the power of the St. Joseph River, establishing a dam. Using turbines for power, factories quickly set up on the East and West Races of the river. Almost every major manufacturer had their beginnings on the East Race. The only exception was the Studebaker brothers, who set up their first blacksmith shop on Michigan Street. By 1930, there were 400 establishments employing 30,000 men and 5,000 women. Studebaker, the Oliver Chilled Plow Company, and the Singer Manufacturing Company were the largest employers.

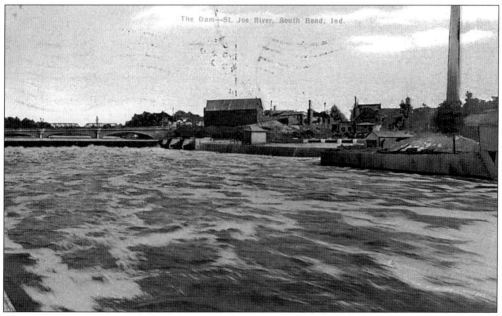

The dam on the St. Joseph River originated in 1843. It harnessed the river's powerful current and provided energy for manufacturers on the East and West Races.

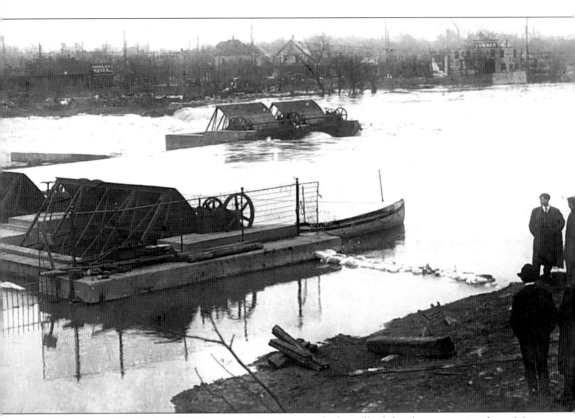

Flooding on the St. Joseph River was quite common before all of the dams were in place. Major floods occurred in 1887, 1908, and 1950. This 1908 real photo post card shows South Bend officials getting up close and personal as they survey the Taintor Gates. The dam and gates were inspected regularly to ensure that the rapidly rolling water did not undermine the concrete foundation.

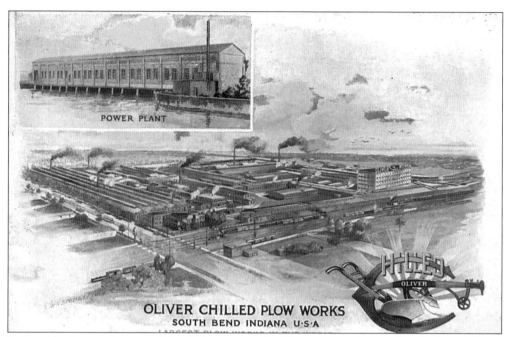

POWER PLANT

OLIVER CHILLED PLOW WORKS
SOUTH BEND INDIANA U·S·A

In its early days, at the turn of the 20th century, the Oliver power plant on the St. Joseph River provided electricity for the entire Oliver factory, located on the East Race, as well as providing electricity to South Bend.

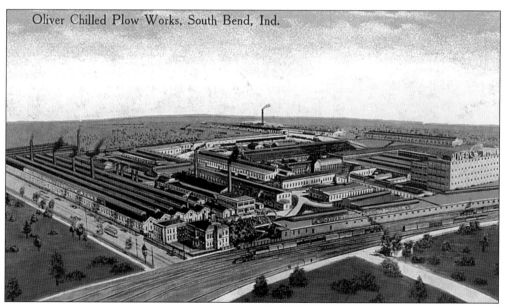

Oliver Chilled Plow Works, South Bend, Ind.

The Oliver Chilled Plow Company boasted that it was the largest plow manufacturing company in the world. It outgrew its limited space on the East Race and constructed a new factory on Chapin Street. As the company continued to enlarge its facilities, the power plant on the St. Joseph River proved inadequate for its needs, and a new power plant was constructed. But times changed. By the 1970s, most of its buildings were abandoned. Now all of the buildings are gone except for the power plant (with the smokestack). This building is now a historical landmark.

In 1852, Henry and Clem Studebaker formed a blacksmithing partnership that included the manufacture of wagons and carriages. From meager beginnings, the Studebaker brothers forged the largest wagon manufacturing company in the world. The company was the only wagon manufacturer in the United States to successfully make the transition from wagons and carriages to automobiles. The last automobile rolled off the Studebaker assembly line on December 20, 1963.

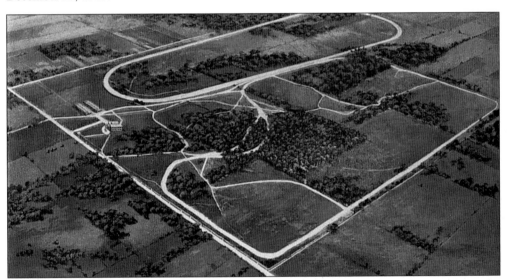

Like all automobile manufacturers, the Studebaker Company proudly claimed its cars were the best in the world. But it went one step further than its competitors. In 1926, the company created the first controlled outdoor proving grounds so that they could test their products under a series of actual road conditions. The proving grounds were located 12 miles west of town on State Road 2. In 1937, the company planted 5,000 pine trees that would eventually spell out the word "Studebaker." Today, the proving grounds are used by A. M. General for testing the Hummer. The portion of the land with the pine trees is now Bendix Woods County Park.

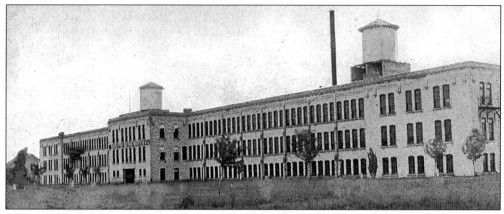

Clement Studebaker Jr. purchased the Columbus Watch Company (of Columbus, Ohio) in 1902, and immediately brought its equipment and materials to South Bend, where he began manufacturing South Bend Watches. The South Bend Watch Company was located at 1720 Mishawaka Avenue and soon grew prosperous. At the height of its manufacturing, its 600 employees were producing 60,000 watches each year. Using the same manufacturing equipment and materials, the company also produced the Studebaker Watch. Although the company was successful for many years, it failed to respond to the growing demand for wristwatches, and the company slowly lost its market. The company closed on January 1, 1930. On July 9, 1957, the abandoned factory burned down. The land was sold to the Associates Investment Company for their national headquarters. When Associates decided to leave South Bend in 1975, they sold the building to Indiana University at South Bend for their administration building.

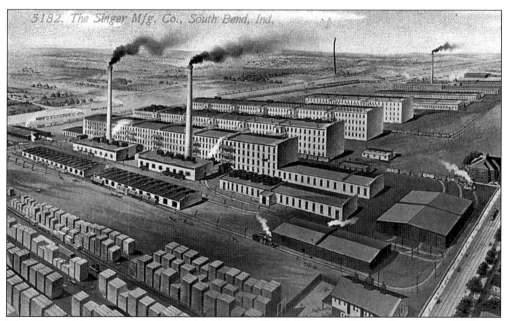

The Singer Manufacturing Company came to South Bend in 1868, where it established a factory for making sewing cabinets for Singer Sewing Machines. At the height of its production, the factory made 80 percent of the cabinets used in Singer Sewing Machines worldwide. But the company fell on hard times, and consumer tastes changed. The entire factory in South Bend was permanently shut down in 1955.

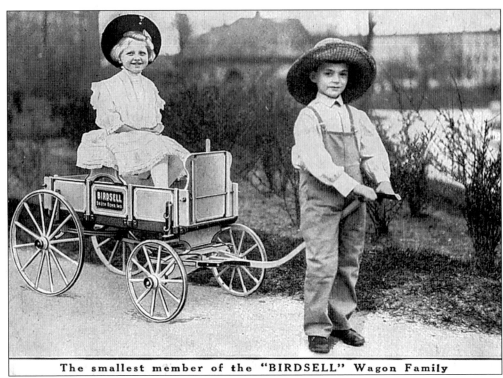

The smallest member of the "BIRDSELL" Wagon Family

John Birdsell manufactured clover hullers (machines for separating clover seed from the straw) and farm wagons, and the Studebaker Company made various kinds of wagons, but the South Bend Toy Company made miniature reproductions of both wagons for children. They were popular Christmas gifts and advertised in the *South Bend Tribune*.

Seven
CHURCHES

The first religious services in the South Bend area were held at the small log chapel established by Father Badin in 1830. This log cabin would later form the nucleus for the University of Notre Dame du Lac. In the town, services were held in taverns owned by Calvin Lilly and Benjamin Coquillard. In 1930, there were 85 churches, serving all religious denominations.

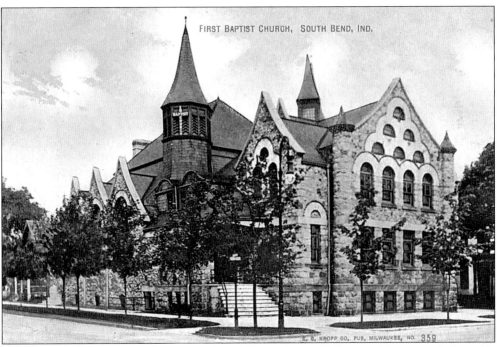

The First Baptist Church was organized in 1836 and occupied several locations before this impressive building was constructed on the northwest corner of Main and Wayne Streets. The church was erected in 1886 and served the community well until it was torn down during urban renewal in the 1960s.

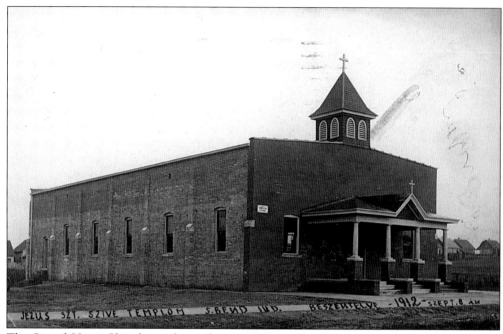

The Sacred Heart Church was located at 1126 West Thomas Street and served the Belgian community for many years. Microfilm copies of church records show that some of the parishioners were Hungarian.

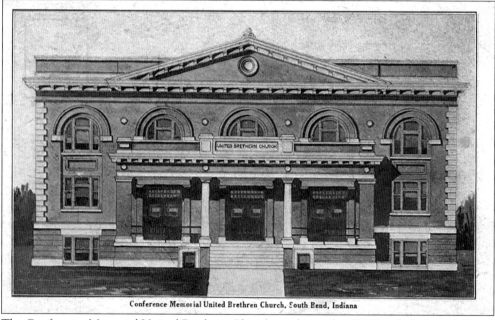

Conference Memorial United Brethren Church, South Bend, Indiana

The Conference Memorial United Brethren Church was located at 608 South St. Joseph Street as early as 1912. It later became the Central United Methodist Church and is now the River of Life of Michiana Church.

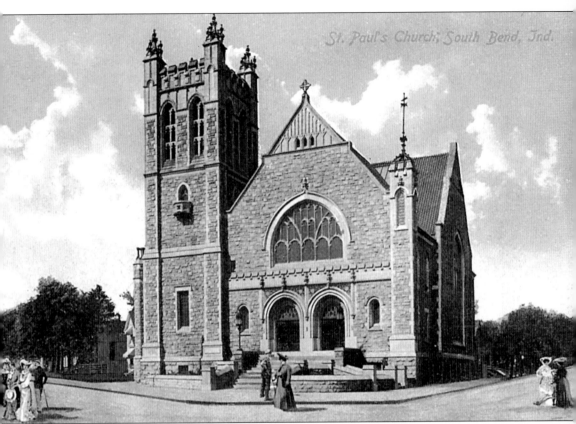

St. Paul's Memorial Methodist Church stands at the intersection of Colfax Street and La Porte Avenue. The cornerstone was laid on May 12, 1901. Money for its construction was donated by Clement Studebaker, but he died before the church was completed. Studebaker and his wife and children were strong Methodists and often led church services.

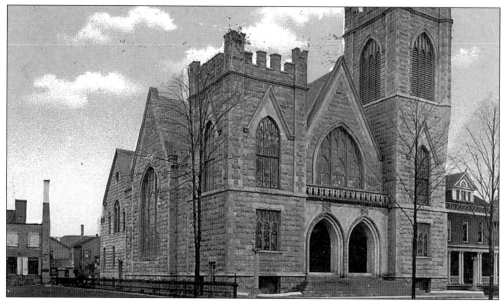

The First Christian Church stood at 320 South Main Street on the site of the first church building. This was the third building. It was dedicated in 1910 and served a long useful life for its members until it was evacuated and sold to the South Bend Redevelopment Department in 1970, which then razed the building. A Goodyear Service Station was then erected on this site. Later, the Goodyear building was purchased and demolished and the lot sold to the St. Joseph County Public Library for parking.

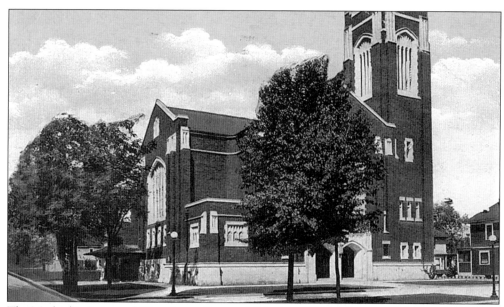

The Methodist Episcopal Church was first established in 1831 by Reverend Nehemiah Griffith. By 1835, the congregation had erected a small frame church on Main Street. The congregation had three buildings between 1835 and 1914. The previous building stood at the corner of Main and Jefferson Streets from 1871 until 1913, when the valuable property was sold and this new building was constructed at 325–329 North Main Street. The building was expanded in 1957.

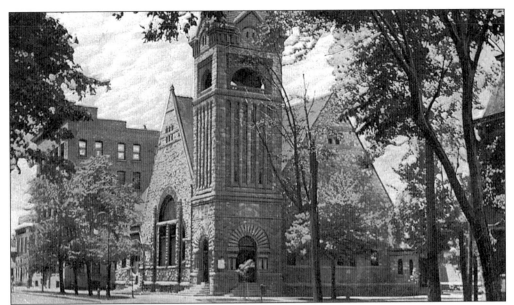

The First Presbyterian Church at 302 West Washington Street reflects the true stonemason's art. Stonemasons used hammers ranging from 2 to 20 pounds to break large stones to reveal the true colors found inside. This was the fourth building for the First Presbyterian Church congregation. Construction began in 1888, and the church was dedicated on June 23, 1889. The cost was about $35,000. One third of the money was raised by the congregation, one third of it was paid by John M. Studebaker, and the final third was paid by Mrs. James Oliver. The congregation moved to a new building in 1953, and this fine structure has served the religious needs of many different faiths since that time.

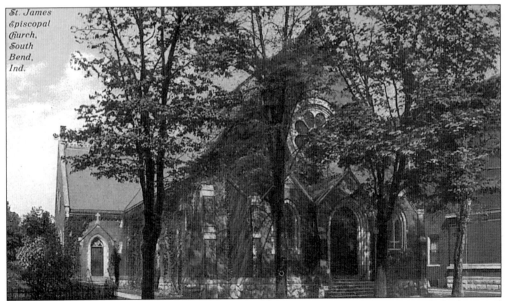

St. James Episcopal Church was organized as a parish in 1868, and the parish had several buildings before constructing this church at 117 North Lafayette Street in 1894. In 1957, St. James became the cathedral for the Diocese of Northern Indiana.

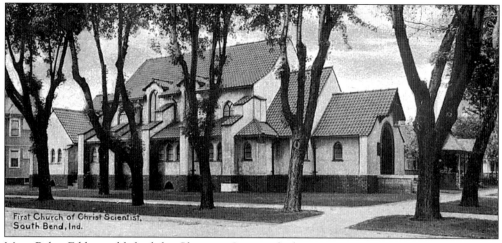

First Church of Christ Scientist, South Bend, Ind.

Mary Baker Eddy established the Christian Science faith in 1898. By 1905, over 100 Christian Scientists were living in South Bend and meeting on Sundays at the Auditorium Annex. The first church was established at 403 North Main Street and dedicated on July 8, 1906. The foundation was of paving brick, and the body was framework covered with plaster. The overall look of the interior was green, with a green carpet and doors upholstered in green. The inside church walls bore Bible verses in gold lettering. The building was constructed in the fall of 1905 and seated 350 people. Curiously, this church looks just like the church identified as the first St. Patrick's Church located on Division Street (now Western Avenue) built in 1858. The picture can be found in the book *One Hundredth Anniversary: St. Patrick's Church, 1858– 1958: A Century at St. Patrick's.*

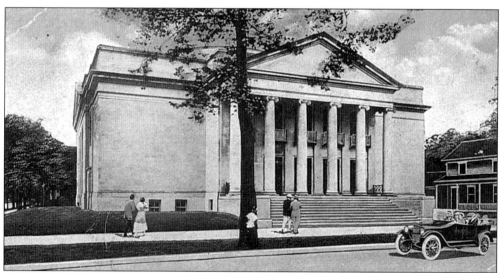

Within a decade, the original Christian Science church building had become too small. It was demolished and a new building was constructed on its site in 1916. With the help of J. M. Studebaker, the debt was paid off and the new church was dedicated in April 1918. It was sold to the Scottish Right Masonic Temple in 1982. On December 31, 2004, the building was sold to the South Bend Civic Theater. After renovation, the grand opening will be held in January 2007. Theater goers will see the original marble-ornamented lobby and sit under a spectacular renovated, windowed dome.

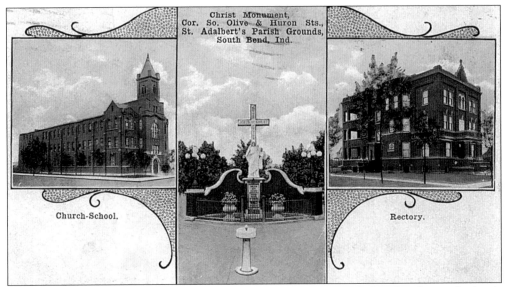

Christ Monument,
Cor. So. Olive & Huron Sts.,
St. Adalbert's Parish Grounds,
South Bend. Ind.

Church-School.

Rectory.

In 1902, several Polish families complained that the existing Catholic churches and schools serving Polish populations (St. Stanislaus and St. Casimer's) were too far away from them, and they wanted to establish a church and school closer to them. They chose the name St. Adalbert's, and after seven years of saving money and planning socials, bazaars, and picnics, the congregation prepared the foundation for the combined church and school at Olive and Grace Streets. The new church was dedicated on September 4, 1911.

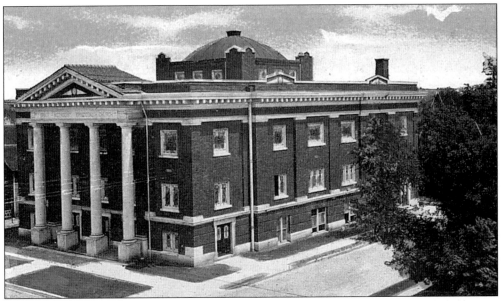

Grace Methodist Episcopal Church was the second church established by the Methodists. It had its inception in 1869, and in 1915, the congregation built this magnificent church at 760 South Michigan Street. The congregation continued to grow, and a new church was later erected at 3012 South Twyckenham. In 1956, the Greek Orthodox parish of St. Andrews moved from its former building at 416 West Jefferson Boulevard. Later St. Andrews built a new church on Ironwood Road, but this building continues to serve various religious denominations.

Welcome to your new Community

We are glad that you are going to be our neighbor, and we hope you will worship with us.

I went with them to the house of God.
—Psalm 42:4

Come Next Sunday

Churches were always seeking new ways to increase their membership. This 1955 postcard was used by the Wesleyan Methodist Church at 3702 South Michigan Street.

(*opposite*) The first St. Patrick's Church was established on Division Street (now Western Avenue) in 1858. The church held 350 people, but the increasing Catholic population soon made it clear that a new church was needed, and in 1886, the cornerstone for the new church was laid. The building was completed in 1887 and held 850 people. This imposing structure still stands at 307 South Taylor Street.

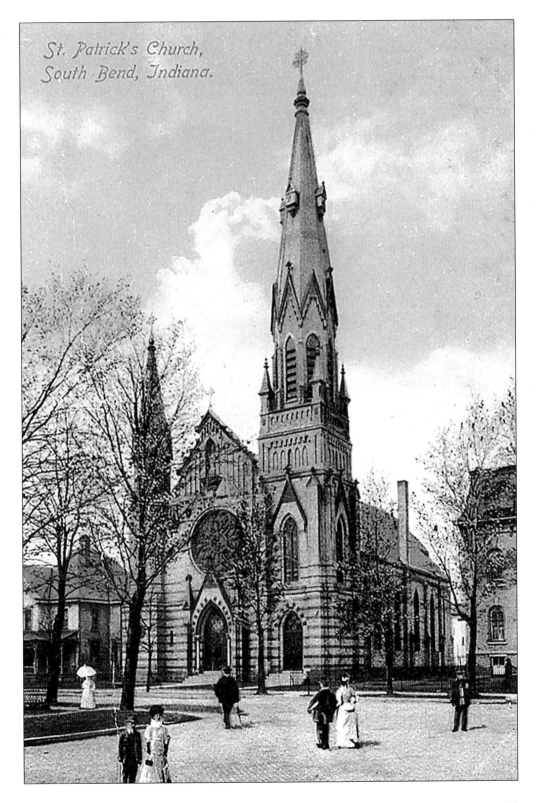

St. Patrick's Church,
South Bend, Indiana.

73

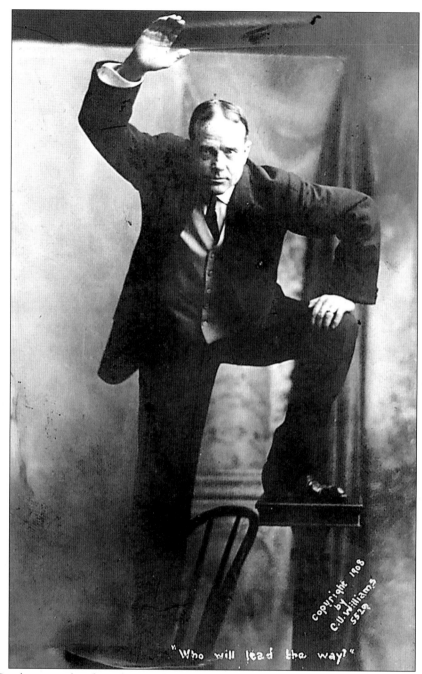

"Who will lead the way?"

Billy Sunday was already a famous baseball player when he turned to preaching between baseball seasons. After his baseball career, he became a full-time preacher, often giving week-long revivals. He was noted for his grand sliding entrances onto the stage in front of his audiences, reminiscent of sliding into third base. Beginning on April 27, 1913, Sunday spent seven weeks evangelizing in South Bend. Sunday gave three separate sermons on opening day. Attendance at the morning sermon was 7,000, while 4,000 attended the afternoon sermon and 8,000 people attended the evening sermon.

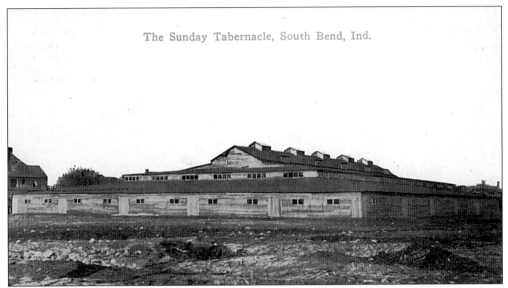

The Sunday Tabernacle, South Bend, Ind.

Construction workers spent nearly 2 months erecting a large wooden structure, capable of housing an audience of 10,000, on Vistula Avenue between Monroe and South Streets. It was convenient to the business center and located only a short distance from the interurban.

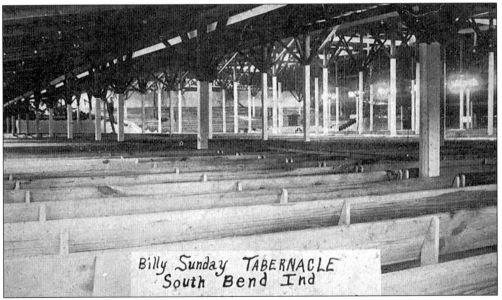

Billy Sunday TABERNACLE
South Bend Ind

Even before Sunday had given his first sermon, several South Bend businessmen were starting a movement to keep the tabernacle after Sunday was finished with his evangelizing. Some believed that it could be used as an exhibition hall or an auditorium. Nothing came of the plan, however. In July, members of Trinity Methodist Episcopal Church met for the first time in their newly completed tabernacle. They sat on the same seats which had been used in Sunday's tabernacle, and a portion of the roof over their heads was made from Sunday's tabernacle. A fire started in the field to the north of the Methodist tabernacle, spread in the tall, dry grass, and moved rapidly toward the tabernacle. Two fire companies were needed to put out the fire. The fire stopped when it had come within a few feet of the building.

He that hath pity upon the poor lendeth to the Lord; and tha which he hath given will He pay him again.—Prov. 19-17

Salvation Army
Industrial Department.
DAVID G. COY, Manager.

OUR MOTTO: *To use the waste in furnishing employment for the waste labor.*

The Salvation Army Plan
for Helping the Poor

Has in its object the alleviation of the poor without either pauperizing them or being a drain upon the purses of the philanthropic public. You can help the Army by giving it the accumulation of your lumber room, ward room, kitchen or cellar.

List of Articles.

Paper	Rags	String	Shoes
Rugs	Carpets	Blankets	Furniture
Bags	Rubber	Clothing	Barrels
Stoves	Metals	Boxes	Baby-
Iron	Tools	Crockery	Carriages

Or any articles which when sorted and cleaned represent a cash value. A regular weekly collection will be made—or as often as holder desires.

We can turn same to good account and the proceeds will be used to help poor men and women.

If you have any articles that you would like to dispose of, fill out and return this card and our wagon will call.

Call at _____

On _____

HOME PHONE 1940.
BELL PHONE 23.

The Salvation Army used a unique approach to getting donated items. They printed postcards which could be picked up around town and taken home by the public. People could then fill out the pre-printed card, list an address and a pick-up time, and send the postcard back in the mail.

Eight
EDUCATION

Father Stephen Badin had originally purchased land to establish a school for orphans. However, he was not successful, and the land reverted back to the bishop until Father Edward Sorin established the University of Notre Dame du Lac in 1842. In 1855, he moved the nuns from St. Mary's Academy in Bertrand to South Bend. Schools in South Bend were often small log or wood buildings in which individual men or women taught, sometimes for a commission. The public school system as we know it today did not exist in South Bend until 1875. By 1930, there were 24 public schools including 6 junior and senior high schools. There were 692 teachers educating 19,015 students.

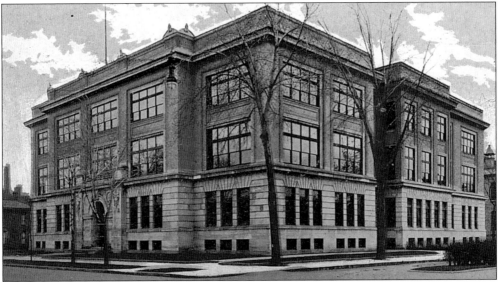

Two previous high schools had been built on the corner of Washington and Williams Streets before this new building on the corner of Market (Colfax) and Williams Streets opened in September 1905. The new building was to ultimately be used as an elementary school, but would serve the purpose of a high school until space could be found to build a larger high school. When a new high school was constructed, this building was then made an intermediate school between the primary schools and the new South Bend High School. When the school structure was changed in 1920, it became the South Bend Junior High School. Shifting student populations later caused the school to be closed and demolished.

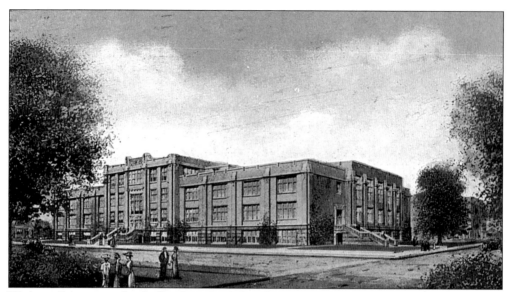

Within a few years, school officials realized that they could no longer postpone building a new high school. The temporary high school was already overcrowded. (A 1911 caricature shows an overcrowded school with pupils hanging out of the windows.) After the death of James Oliver, the city purchased Oliver's land and house, tore town his magnificent home and built this new South Bend High School. The building cost $600,000. It was dedicated in 1913 and opened in 1914. The school was discontinued as a high school in 1970 and now serves as an excellent apartment complex.

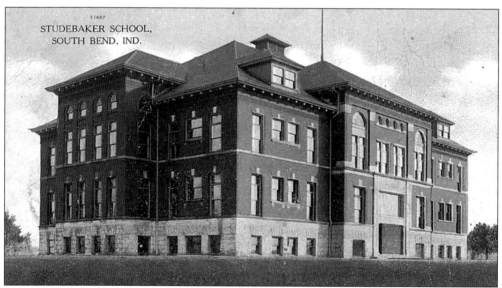

The Henry Studebaker School stood at 1900 Marietta Street (between Dubail and Dayton Streets) on land once owned by Henry Studebaker. The Board of Education spent $113,000 for its construction in 1904. The building fell to the wrecking ball in 1960 at the same time that the new Studebaker Elementary School on Dubail Street was being built. Neighbors were less than pleased with the noise. The new school was being constructed during the day while the old school was being torn down at night.

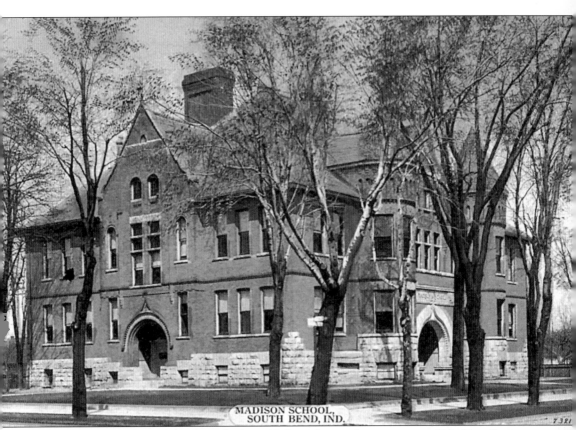

MADISON SCHOOL,
SOUTH BEND, IND.

The first James Madison School was built in 1862 at the northwest corner of Madison Street and Lafayette Boulevard, and was replaced in 1893 with this red-brick building. The school had stone trim and a slate roof. The total cost of the building was $25,000. It was abandoned in 1929, but later served as a food distribution center for the Portage Township Trustee, before being razed in 1946. Temple Beth-El now stands on this spot.

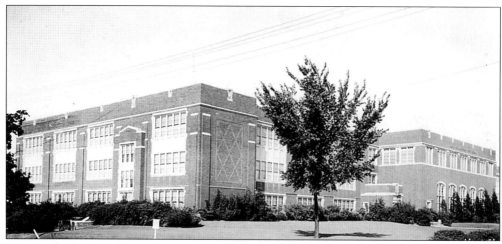

James Whitcomb Riley High School, near the corner of Fellows and Ewing Streets, was originally constructed, in 1924, as South East Junior High School. The name was later changed to James Whitcomb Riley Junior-Senior High School. The first high school graduating class was in 1931. In the late 1990s, changing times and demographics caused the South Bend Community School Corporation to consider closing the school. Instead, the old high school was demolished in 1999 and a new high school was built.

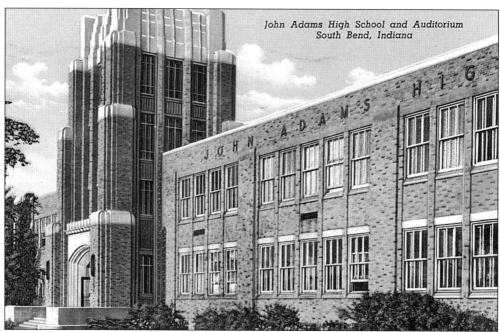

Due to stepped up pre-war efforts, South Bend's population was booming overnight. Both Central High School and James Whitcomb Riley High School were becoming overcrowded. Using funding available through the Public Works Administration, John Adams High School was built in a corn field on Mishawaka Avenue near Potawatomi Park. It opened in 1940, and the first graduating class was in 1942. In 1996, the South Bend Community School Corporation considered closing the school, but local efforts saved it. Adams is currently finishing a major remodeling and expansion project.

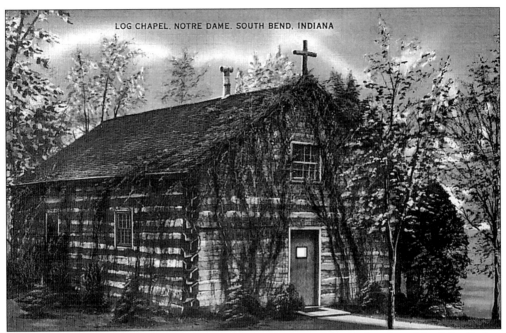

LOG CHAPEL. NOTRE DAME. SOUTH BEND, INDIANA

This log chapel on the Notre Dame Campus is a reproduction of the chapel built by Father Stephen Badin in 1831. The original chapel had burned long before. The 1906 reproduction is based on reminiscences of brothers who had been in the original cabin and a manuscript.

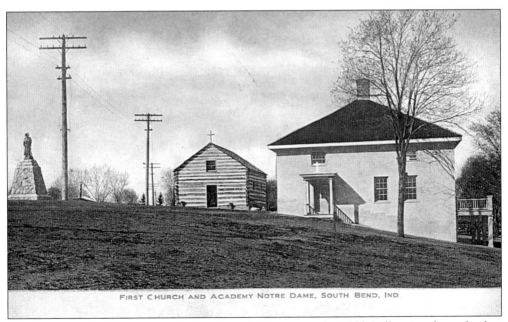

FIRST CHURCH AND ACADEMY NOTRE DAME, SOUTH BEND, IND

This four-story building next to the log chapel is known as the "Old College" and was the first building that Sorin erected (1842). During its long life, it served as a dormitory, a convent, a farmhouse, a bakery, and headquarters for the Holy Cross Missionary Band.

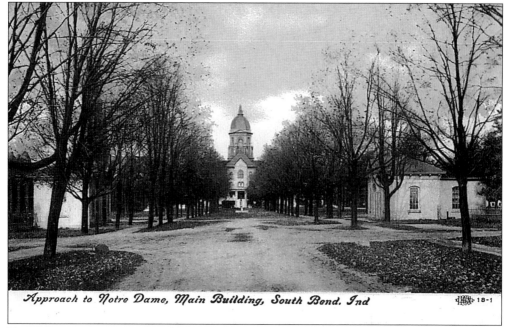

Approach to Notre Dame, Main Building, South Bend. Ind 18-1

Notre Dame Avenue is pictured here in the old days, when it was still unpaved. Directly ahead is the administration building. The structure on the right is the post office.

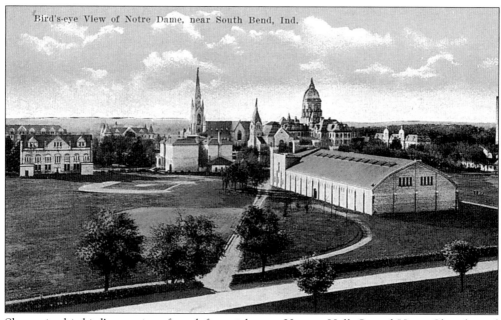

Bird's-eye View of Notre Dame, near South Bend, Ind.

Shown in this bird's-eye view, from left to right, are Hoynes Hall, Sacred Heart Church, and the administration building. In the foreground is the field house.

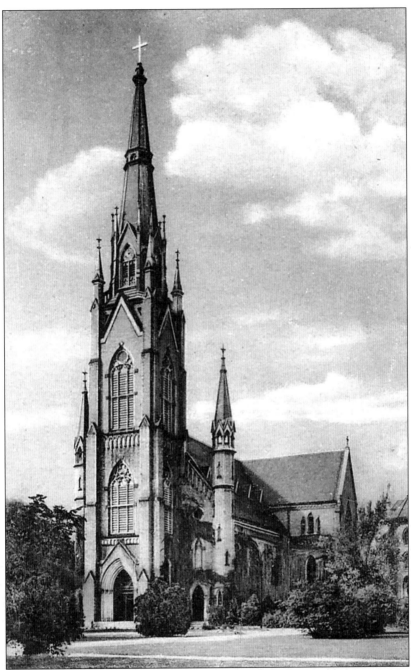

Sacred Heart Church (now Sacred Heart Basilica) is the third-largest church to be built on the campus (not including the log chapel). Following the traditional Latin Cross, it is 275 feet long and 114 feet wide. The foundation was laid in 1870, but it took 17 years to complete the building because of financial difficulties. When finished, it had 42 large, stained-glass windows, 114 life-size figures, and 106 smaller ones. The stained-glass windows were protected on the outside by rigid screening. The screening saved the windows during a terrible storm in 1886, while thousands of windows were destroyed in nearby South Bend.

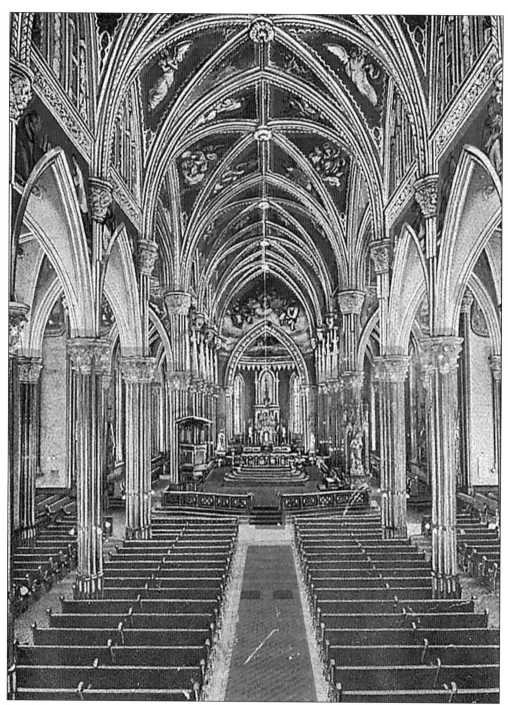

Luigi Gregori spent 4 years painting walls and 141 murals for the church, and the Carmel Du Mans Studio in Le Mans, France, created 116 stained-glass windows for the building. Over the years, smoke and dust slowly accumulated on the murals, ceiling, and walls, hiding their original glory. The basilica has been restored three times, with a multi-million dollar restoration in the 1990s again revealing the magnificent detail that Gregori had created.

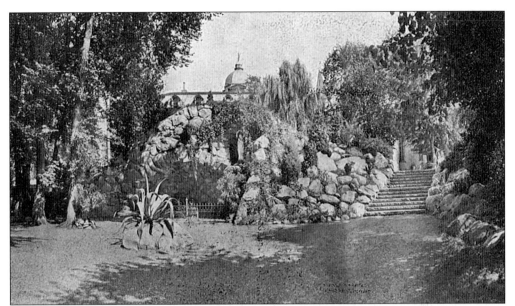

Father Sorin had returned to France several times. In 1876, he visited Lourdes and was so impressed that he felt compelled to create an exact replica of it on campus. However, it took another 20 years before work began on the replica. When completed, the Grotto was only 1/7 the size of the French shrine.

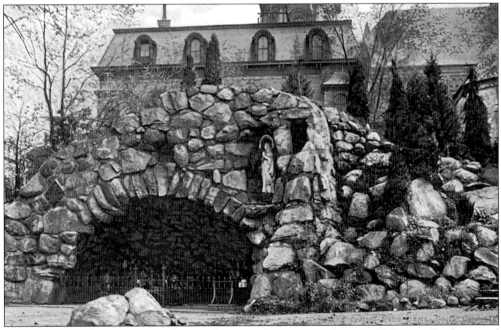

The Grotto has been a source of peace, hope, and inspiration for over 100 years. Students and visitors come here to pray for victories in sports, to pray for consolation after the loss of a loved one, to find peace when battling disease, and to pray for peace in times of war. Many people have remarked on what the Grotto has meant to them. Some of their stories have been collected in books and on a website.

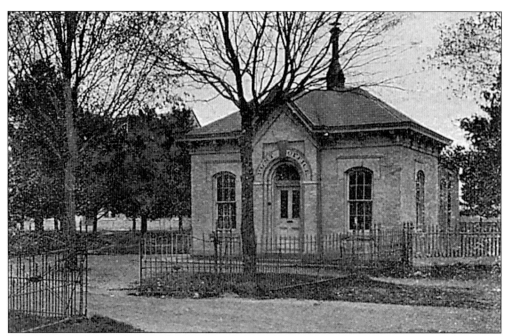

Father Sorin believed that the college could only thrive if it separated itself from the neighboring city of South Bend. Notre Dame needed its own identity. He began to establish this identity when he insisted that Notre Dame should have its own post office. However, the U.S. Postmaster felt that the college was close enough to South Bend that it did not need a post office of its own. Finally, through the intercession of Henry Clay, the postmaster allowed Notre Dame to have its own post office in 1851.

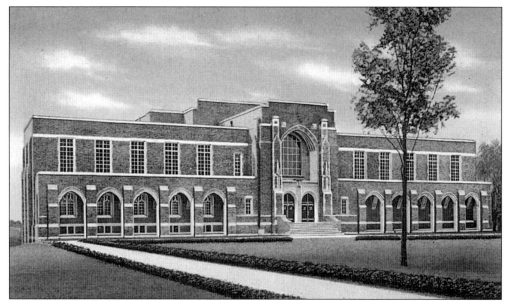

The Rockne Memorial was built in 1937 as a tribute to the coach who had done so much for the university. It contained all of Rockne's trophies, as well as other sports trophies. Also in the building were a swimming pool, a solarium, basketball gyms, and other athletic offices.

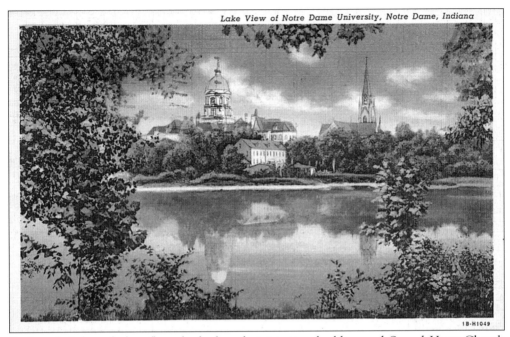

St. Joseph Lake calmly reflects both the administration building and Sacred Heart Church (now Sacred Heart Basilica). This view has been captured in numerous photographs, postcards, and paintings.

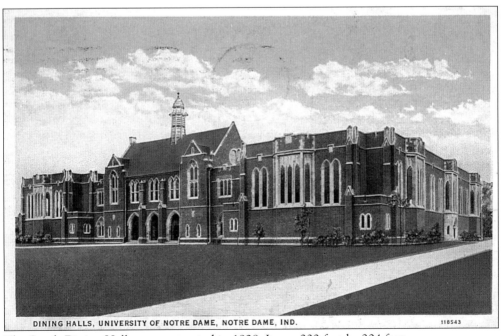

DINING HALLS, UNIVERSITY OF NOTRE DAME, NOTRE DAME, IND. 118543

The South Dining Hall was constructed in 1928. It was 232 feet by 204 feet.

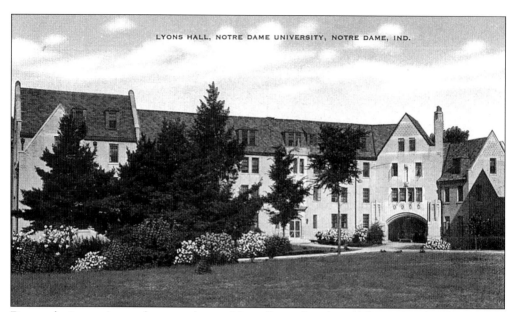

LYONS HALL, NOTRE DAME UNIVERSITY, NOTRE DAME, IND.

Due to the increasing student population, Notre Dame found itself short of student housing. It attempted to solve the housing problem by building two temporary residences and three permanent residences, including Lyons Hall. The hall contains a great arch allowing visitors a magnificent view of St. Mary's Lake.

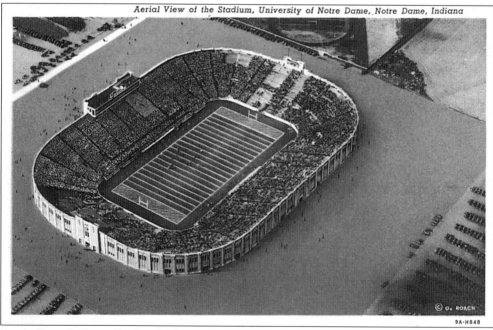

Aerial View of the Stadium, University of Notre Dame, Notre Dame, Indiana

Football coach Knute Rockne built an impressive record as the most winning football coach in Notre Dame history. His victorious teams drew in tens of thousands of visitors each season, finally outgrowing the football stadium. This view shows the stadium most people associate with Notre Dame football. It is known as the "Stadium that Rockne Built." A new stadium was built in the 1990s, encompassing the old stadium.

The Avenue, St.Mary's College,
Notre Dame, Ind.

Father Sorin soon realized that he needed nuns to do the basic cleaning, mending, cooking, and similar duties, as well as teaching young women the basics of a good education. He returned to France, secured several nuns to accompany him back to South Bend, and then set about establishing St. Mary's Academy. However, due to conflicts with the bishop overseeing the establishment of the academy, Sorin first organized the school in Bertrand, Michigan, in 1844. In 1855, Sorin moved the academy to land which adjoined the University of Notre Dame.

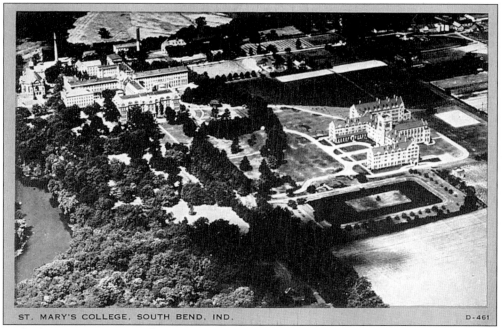

ST. MARY'S COLLEGE, SOUTH BEND, IND. D-461

In the beginning, nuns taught young girls all the basic home economy and educational skills. From its small beginnings in one building, St. Mary's has grown to be a major influence in liberal arts education. By 1900, nearly 200 Sisters of the Holy Cross were living at the Academy. Holy Cross Hall, Le Mans Hall, Lourdes Hall, St. Joseph's Hall, and O'Laughlin Auditorium are among the buildings which have been added to the campus.

89

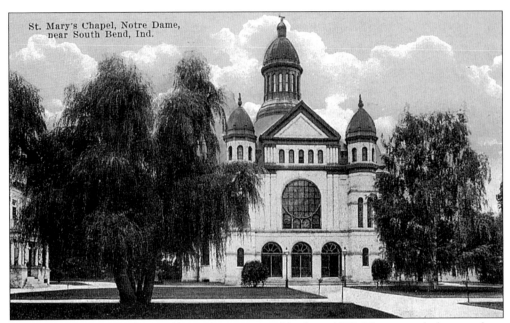

St. Mary's Chapel was designed by Father Sorin and built in 1858. The stained-glass windows came from Le Mans, France, and the Stations of the Cross were made by one of the nuns at the school. Unfortunately, she died before she had completed them. A 1954 survey found the building in very bad shape. A major renovation in the 1990s changed much of the church interior and drew some criticism.

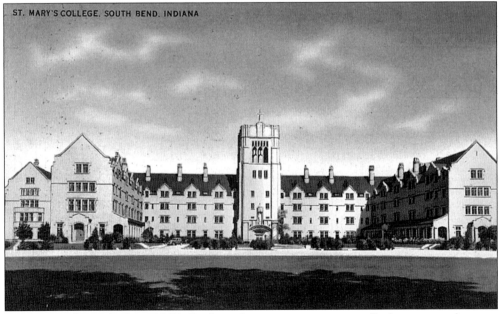

Le Mans Hall was built in 1925. Students have many stories to tell about unusual events occurring in the building. Some claim there are ghosts.

Nine
SUBURBAN AREAS AND INDIVIDUAL HOMES

South Bend's sprawling population moved west first, filling in areas on Washington Street and adjoining streets in the 1850s and 1860s. Then the population slowly moved northwest along the Michigan Road (now Lincoln Way West). By 1890, suburbs were beginning to spring up across the St. Joseph River on the north side of the bank. Washington Street drew the elite during the 1860s through the 1880s, but by the 1890s the elite were slowly moving to newly established Chapin Park and Riverside Drive areas. Included in these newly platted areas was "Navarre Place," named for Pierre Navarre, whose cabin was originally located here nearly 70 years before. By 1930, there were 110,000 people living in South Bend.

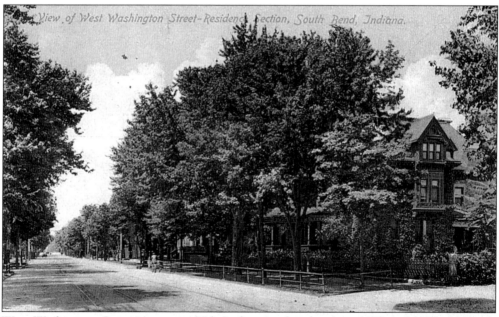

West Washington Street was one of "the" places to live between 1870 and 1930. Although mayors, bankers, lawyers and dentists lived here, the most prominent people residing on this street were Joseph Oliver (Copshaholm), Clem Studebaker (Tippecanoe Place), and Peter Studebaker.

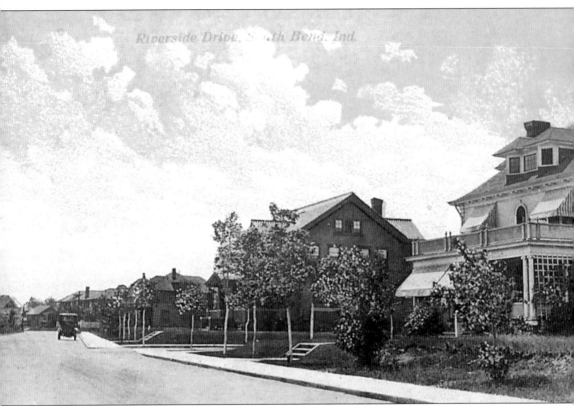

In 1909, several small streets with individual names were changed to Riverside Drive. The drive was established by the city as an impressive way of showing off the St. Joseph River. Beginning on Michigan Street, it skirts Leeper Park, then winds westward and finally north, along the course of the St. Joseph River; it offers a boating launch site as well as several small park-like areas for picnics. Following Riverside Drive from Michigan Street until it ends at Darden Road is like taking a brief architectural survey of South Bend, beginning with houses developed in the early 1900s (near Leeper Park) and continuing to houses under construction today (near Darden Road). Riverside Drive was completed as far as Darden Road in 1922, but did not continue northward from that point. Enthusiastic supporters suggested that the drive be constructed all the way to St. Joseph, Michigan, where the river empties into Lake Michigan.

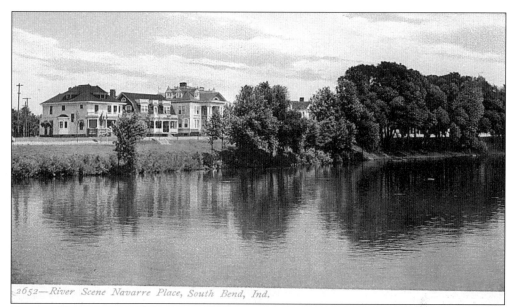

2652—River Scene Navarre Place, South Bend, Ind.

Navarre Place was established as a suburb in 1903. It was named for Pierre Navarre, who established his trading post and home in 1820 only a few hundred feet away from this postcard scene. The Navarre family held the land until 1863, when they sold it. The trading post was moved to Leeper Park in 1904.

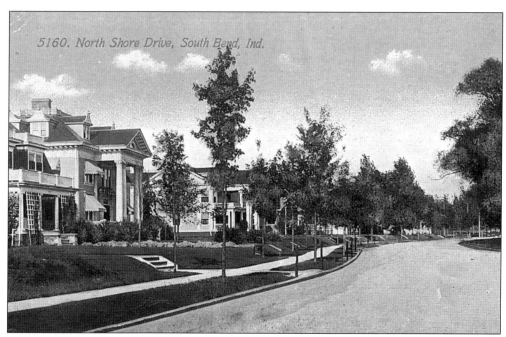

5160. North Shore Drive, South Bend, Ind.

North Shore Drive is on the north side of the St. Joseph River. Technically, it is part of the Navarre Place suburban area. The houses shown in this postcard were built between 1904 and 1906.

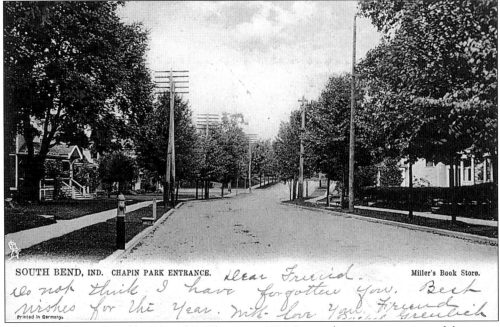

SOUTH BEND, IND. CHAPIN PARK ENTRANCE. *Dear Friend.* Miller's Book Store.
do not think I have forgotten you. Best wishes for the Year. With love your Friend Greulich
Printed in Germany.

Chapin Park was platted by Edward P. Chapin in 1890. It was the western portion of the estate of his father, Horatio Chapin, who purchased the land in 1855. Edward P. Chapin wanted a luxurious house not far from the city, and also wanted to provide housing for South Benders sharing his upscale lifestyle. Shortly after he platted the land, his sister Mary platted the eastern portion of their father's estate. Most of the houses were built before 1910.

Forest Avenue was part of the Chapin Park area platted by Edward Chapin. Chapin lived at 856 Forest Avenue. His neighbors were Paul Beyer (owner of Beyer Floral Company), Henry S. Miller (owner of Miller's Book Store), William Happ (real estate), Mrs. Caroline Schaefer (China Decorating Studio), and Lloyd Greenan (Secretary for the South Bend and Mishawaka Fire Underwriters Association).

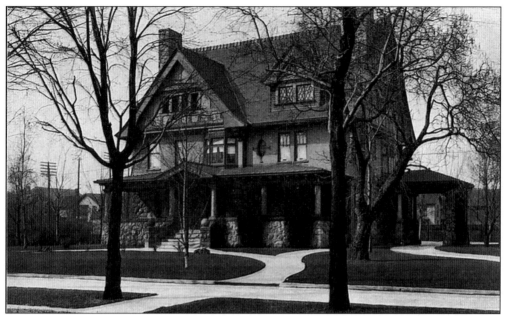

Joseph Benjamin Birdsell built this house at 511 West Colfax in 1898. He was the treasurer for Birdsell Manufacturing Company until the death of his father in1894. After his father's death, Joseph became president of the company. Joseph died in 1906. His widow, Olive, remained in the house for many years following his death. After she died, it became an office building, known as the Income Building. Among its later occupants was Judge F. Jay Nimtz. It is now a local landmark.

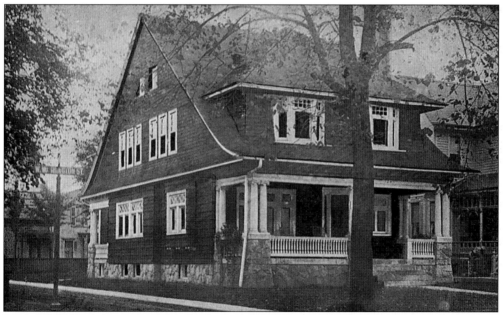

James W. Taylor was secretary for the Indiana Lumber and Manufacturing Company. He built this beautiful residence in 1904 at 724 West Washington Avenue. It is still standing and is in just as good condition today as when it was built 100 years ago.

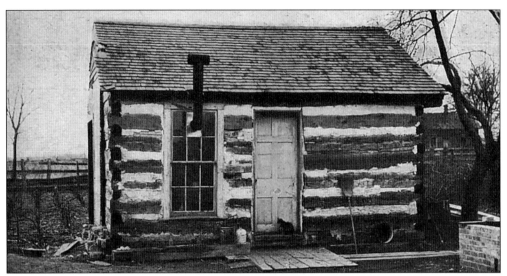

Pierre Freischutz Navarre, agent for the American Fur Company, established a trading post on the St. Joseph River in 1820 near the area now known as Navarre Place. According to George DeGraff, Navarre's grandson, this log cabin belonged to Navarre. However, a 1903 real estate brochure promoting Navarre Place shows a different cabin (the same photograph appears in two early books on St. Joseph County). Early photographs of Leeper Park show several cabins sitting near each other, indicating that at least one cabin was removed from the original site and placed in the park. There are at least six different photographs of "Navarre's cabin," taken at different times. One shows a cabin nearly in ruins, one a cabin with no chimney, one shows a brick chimney, one a field stone chimney, and two photographs claim to show the same building, but one has 11 logs and one has 13. A placard at the cabin in Leeper Park says that it was moved there in 1904. The cabin in this postcard vanished many years ago. An 1894 *South Bend Tribune* article says that the original cabin "disappeared many years ago."

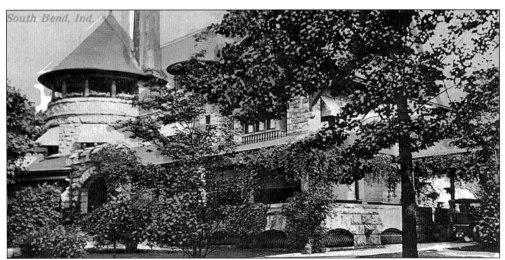

James Oliver, president of the Oliver Chilled Plow Works, built his beautiful house at 325 West Washington Street, where he lived with his wife for many years. After his death on March 2, 1908, the property was purchased by the city and torn down to make space for a new South Bend High School.

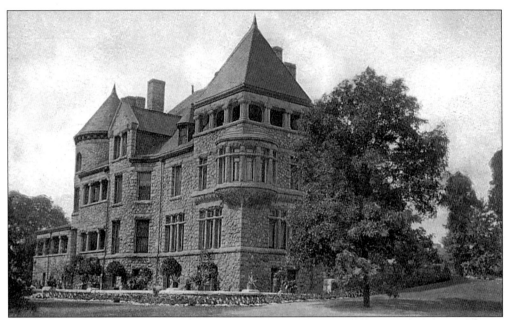

Clement Studebaker built Tippecanoe Place at 620 West Washington Street and named it for William Henry Harrison ("Old Tippecanoe") who was the grandfather of Clem's close friend, President Benjamin Harrison. Construction on Tippecanoe Place was finished in February 1889. On October 9, while in Worcester, Massachusetts, Studebaker received word that the house had been completely gutted by fire. By the time he arrived home, 150 large loads of debris had already been carried away and dumped in the city park. Work began immediately to restore the home. On October 19, Studebaker greeted a visiting Pan American Union delegation in front of his home, apologizing for its condition. Today the house is a landmark, and houses an exceptionally fine restaurant.

While his brother, Clem, had Tippecanoe Place, John Mohler Studebaker had Sunnyside, at 1219 East Jefferson Boulevard. He and his wife, Mary, had lived in numerous houses during their 57 years of marriage, but this was the finest house of them all. On March 17, 1917, J. M. Studebaker died, leaving his estate to his children. The house was torn down about 1950. Some people still remember the area around his home as Sunnyside.

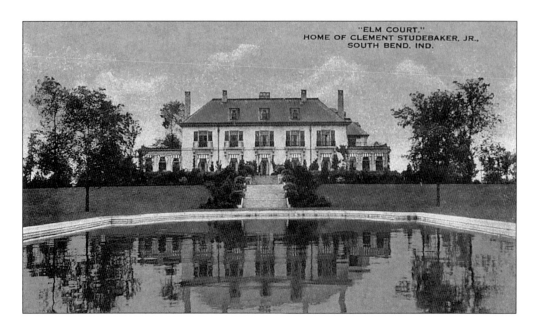

Elm Court, has seen many owners since it was first built by Clement Studebaker Jr. and his wife, Alice Rhawn Studebaker, in 1910 near his uncle's Sunnyside estate. Studebaker owned the 30-room house from 1910 to 1927 and then moved to Chicago to pursue his public utilities business. The swimming pool in front of the house was one of the first concrete swimming pools in South Bend. The house was purchased in 1928 by flamboyant Vincent Bendix, who converted the swimming pool to a sunken garden and built a new swimming pool. His lavish lifestyle bankrupted him by 1938. In 1943, the Sisters of St. Joseph purchased the house. After the mother house was moved to Tipton, Indiana, the house was sold to Trinity School.

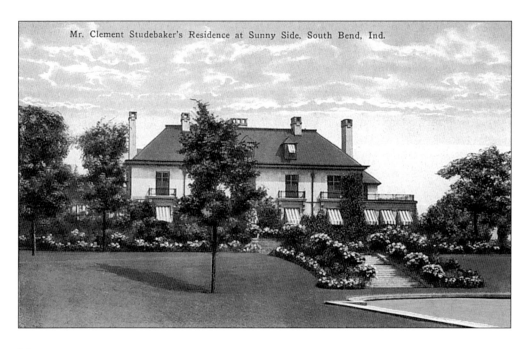

Ten
PARKS AND RECREATION

Ironically, South Bend's town founders were shortsighted when it came to planning for town squares and town parks. The areas set aside for city or county government offices had been adequate, but there were no plans at all for a park of any kind. By the late 1880s, city officials were beginning to recognize the oversight—but they had a problem. Much of the neighboring areas had already been taken up with sprawling homes, or gobbled up by land-hungry factories. The nearest pieces of land which might provide parks were swampy, disease-infested, and certainly not places a person would want to take their family for a picnic. By 1930, however, the city had managed to find space for 24 parks covering 494.82 acres.

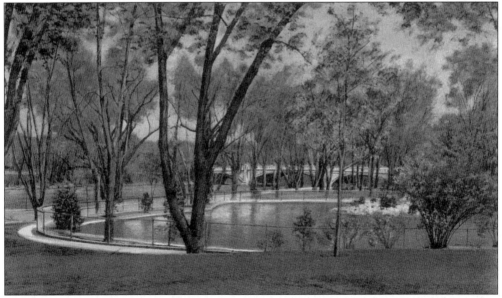

The land that is now Leeper Park was swampy, low to the river, and easily flooded. It had been purchased in 1900 for the use of the Water Works Department, for the capping of several artesian wells, and the construction of the North Pumping Station. After the artesian wells were capped, the land became more suitable for public use, and the area was graded, planted, and improved. It was named after David Rohrer Leeper, a former mayor who lived near the park. The park lies in three sections; one section runs east of Michigan Street, while the central and west sections are west of Michigan Street.

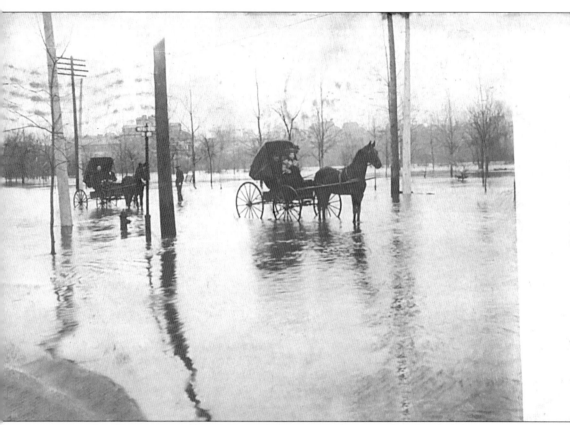

Even after the artesian wells were capped, the St. Joseph River often flooded the park as shown in this 1908 real photo postcard. In April 1950, the St. Joseph River rose so much that it covered most of the park and threatened to wash away the iron bridge to the island. Flooding was a regular inconvenience, until a series of dams were established on the St. Joseph River.

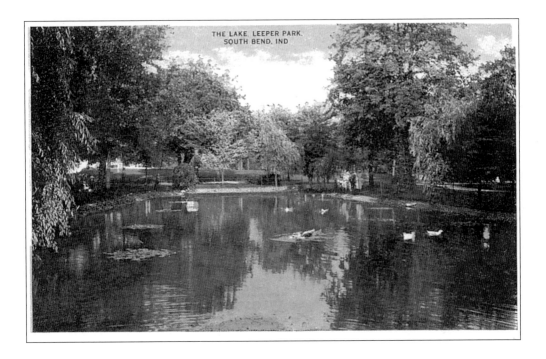

In 1907, two lagoons were built in the central portion of the park. In 1908, the western lagoon was enclosed with an iron fence and stocked with ducks, swan, geese, and other waterfowl; it became known as the duck pond.

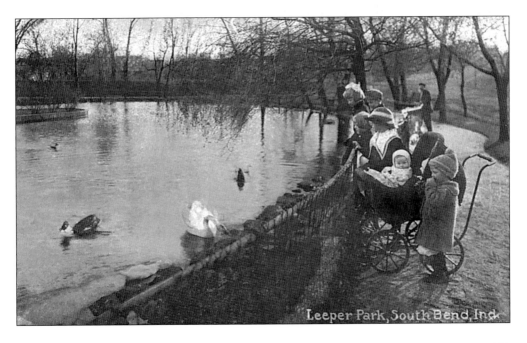

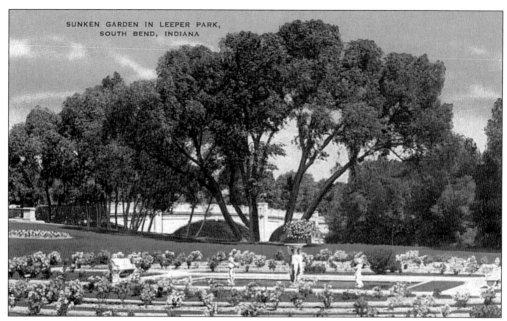

SUNKEN GARDEN IN LEEPER PARK,
SOUTH BEND, INDIANA

Over time, the spring for the eastern lagoon dried up. It was replaced in 1916 with a sunken garden. In 1925, 700 rose bushes were planted in the sunken garden.

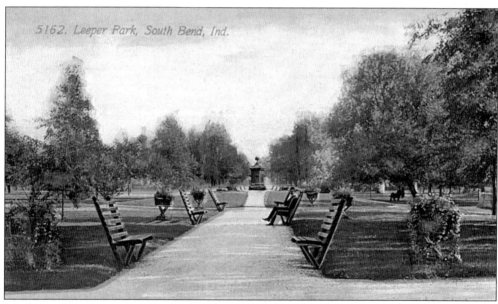

5162. Leeper Park, South Bend, Ind.

South Bend hired noted landscape planner George Kessler to design Leeper Park, as well as the surrounding area including Riverside Drive and North Shore Boulevard. Kessler was one of the leading landscape architects of the "America Beautiful" movement in the early 1900s.

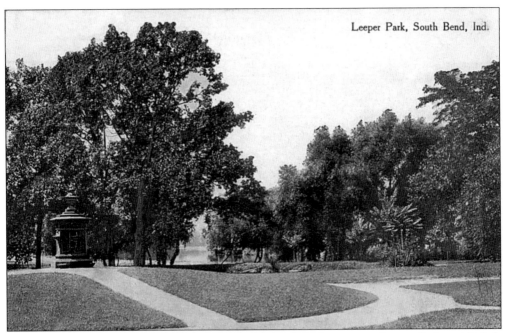

Mary P. Moody Bugbee presented this wonderful drinking fountain to Leeper Park in 1905. It was installed in the central portion of the park southeast of the duck pond.

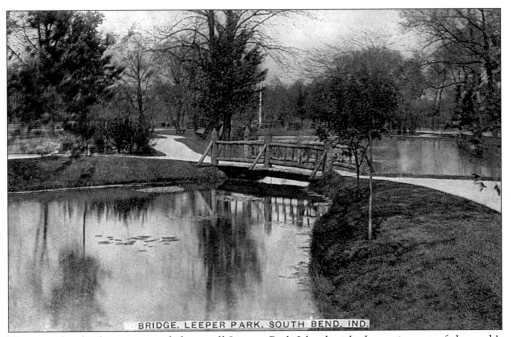

BRIDGE, LEEPER PARK, SOUTH BEND, IND.

This wooden bridge connected the small Leeper Park Island with the main part of the park's east section. It was constructed in 1902, but destroyed in a 1907 flood. It was replaced with an iron and concrete bridge in 1908.

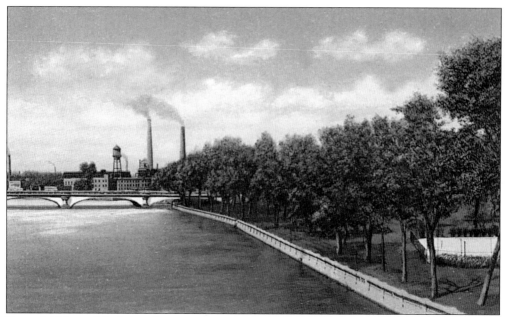

Beautiful Howard Park has the most interesting history of all of South Bend's parks. The low area was easily flooded by the St. Joseph River and natural springs, making the area a swamp where malaria and other diseases were easily spread. Various people owned individual sections of the land and the city had no control over draining the area. In 1878, the city began to purchase individual sections of the land and began a plan for draining the swamp. Maple and elm trees were planted and the low ground was slowly filled in as a city dump. The area was called City Park. It was here that more than 150 large loads of debris from the Tippecanoe Place fire were dumped. In 1894, the Park Board adopted Howard Park as the official park name, and in 1895, a "sea wall" was erected between the St. Joseph River and park land. The official dedication was on August 18, 1899.

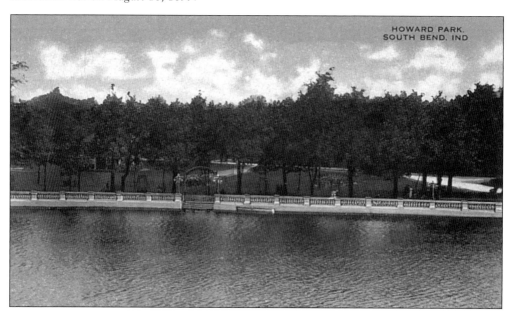

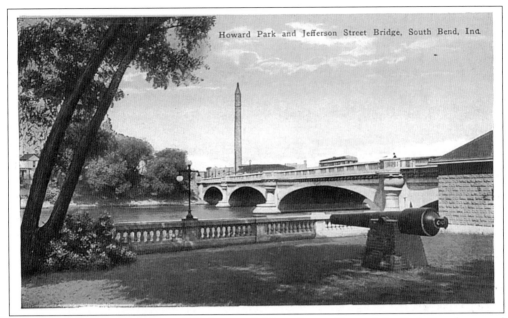

After construction of the "sea wall," Corwin C. Vanpelt, president of the Park Board, secured three cannons which had seen service in the Civil War, and had them mounted overlooking the wall.

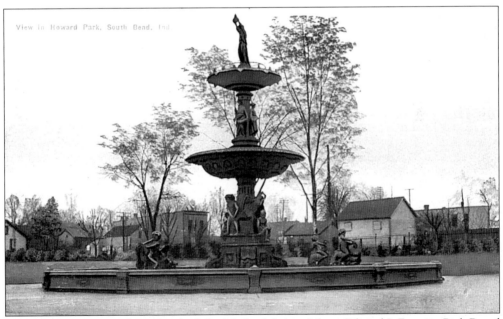

With a rousing series of speeches by John M. Studebaker, Mayor Edward J. Fogerty, Park Board President William A. McInerny, and Honorable Abraham L. Brick, this magnificent electric fountain was formally dedicated on July 21, 1906. Studebaker paid for the fountain. In his remarks, Studebaker said that he had traveled all over the country and seen many parks, and he discovered that the parks most frequented were those made most attractive through private or public enterprise.

105

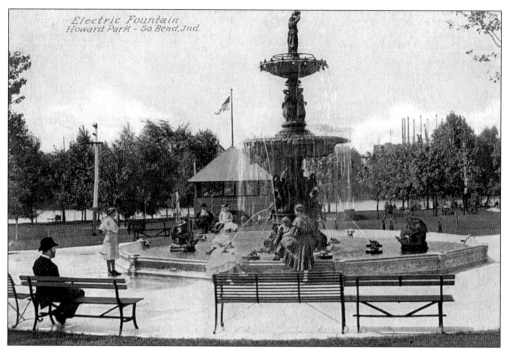

The electric fountain was one of the most photographed parts of Howard Park and was shown from various angles in numerous postcards. The building directly behind the fountain is the band shelter.

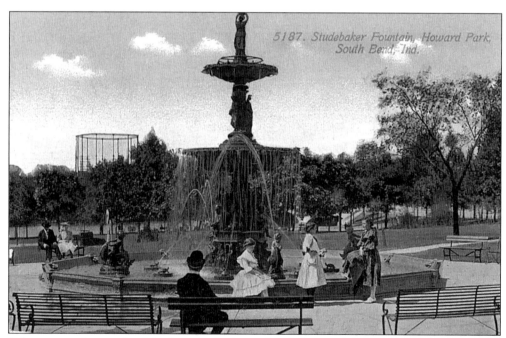

Taken at another angle, this photograph shows the skeleton of the gas tower—which stored natural gas—in the background. When completed, the tower was dark green with a checkered red and white top. It was a major South Bend monument for nearly 60 years before being torn down.

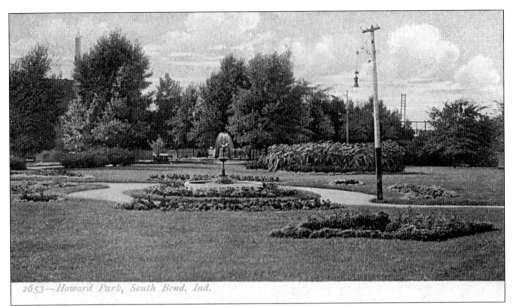

2653—Howard Park, South Bend, Ind.

In June 1907, Calvert H. Defrees, a well-known local contractor, donated a fine drinking fountain to Howard Park. It was made of the same material and by the same company as the Studebaker electric fountain. Sitting on a little knoll on the west side of the main drive, it was northwest of the band pavilion and about 350 feet south of Jefferson Street. The base was 15 feet in diameter and embedded in concrete. Drinking cups for public use were attached with chains to the fountain.

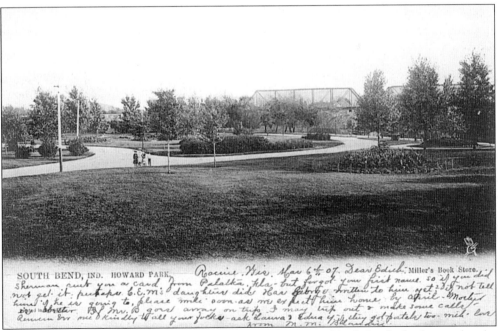

SOUTH BEND, IND. HOWARD PARK.

Walking lanes were well-lighted and covered much of Howard Park. In the background is the railroad bridge. The Northern Indiana & Southern Michigan Railroad was the first company to span the St. Joseph River. Later, the company evolved into the New York Central Railroad.

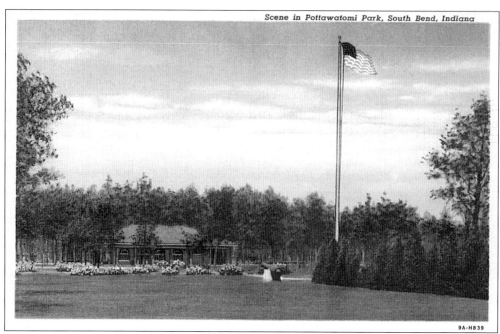

9A-H839

On April 3, 1906, St. Joseph County commissioners turned over the old county fair grounds on Mishawaka Road to South Bend for use as a city park. The city named the roughly 60 acres of rolling and wooded land Pottawatomi Park, in honor of the Pottawatomi Indians who had inhabited the area. The county fair had formerly used 40 acres of the land for its activities, while the remaining 20 acres of fine wooded land on the north were previously a part of the old county farm. (Note—early city directories and other sources use various spellings for Pottawatomi Park, including Pottawattomi Park. Today the spelling has been modified to Potawatomi.)

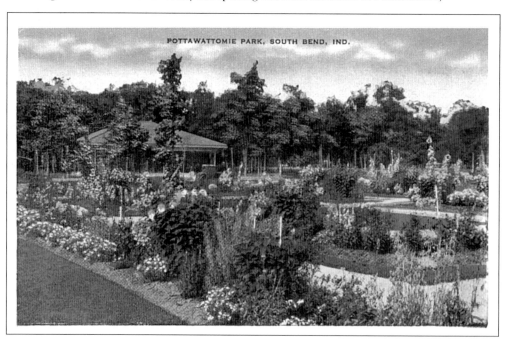

POTTAWATTOMIE PARK, SOUTH BEND, IND.

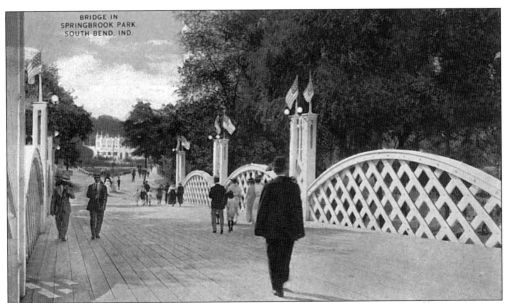

Springbrook Park, according to some sources, had its origins as early as the 1880s, but it did not have the respectability that it later earned until after the Chicago, South Bend & Northern Indiana Railway had purchased the grounds in the 1890s. The interurban ran between South Bend and Mishawaka and purchased the land for a turn-around terminal. Later the company began making plans to enhance the area. The land dropped down in a series of plateaus and banks from Vistula Avenue (now Lincoln Way East) to the St. Joseph River.

By May 1896, the park had an athletic field, a bicycle track, and a grand stand, as well as a band stand, and the plateaus and natural banks had been graded. A lake was filled regularly with pure water, and several of the large granite boulders which had been excavated on the property were strategically moved. Wooden benches were placed all over the grounds, and the original sycamore, cedar, oak, and elm trees were properly trimmed. Refreshment booths were spread out over the grounds.

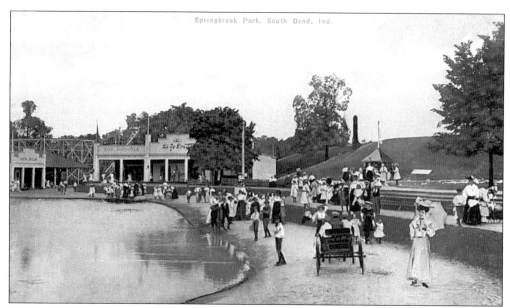

On May 30, 1909, the annual opening of Springbrook Park drew 7,000 people. The Philadelphia opened its refreshment stand offering candy and ice cream. The musical comedy, Mr. *Wall of Wall Street*, was presented in the casino, with a cast of 25 and a chorus of 12. During the week, no admission was charged before 6 p.m.

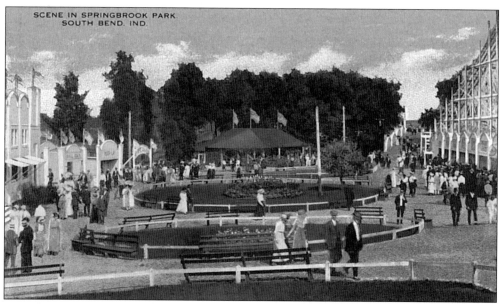

An exhibition hall (on the left of the card) and a casino (in the center of the card) were among the earliest structures built. Sometime before 1912, a roller coaster (on the right) was built. By 1916, a baseball field and race track had been added. Pete Reden moved from Youngstown, Ohio, to South Bend in 1924 to manage the park, and he began a series of renovations including a contest to rename the park. In 1925, Ruth Ann Reed won a $50 gold prize for offering the best name—Playland Park. Cecilia Lang won $25 in gold for naming the new $40,000 roller coaster the "Jack Rabbit."

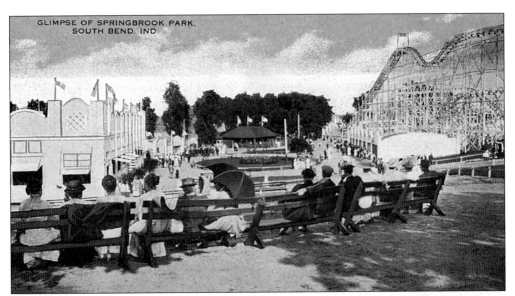

By 1930, the park was completely renovated. A merry-go-round, imported from Germany, featured hand-carved horses. A large 100-foot-by-165-foot swimming pool was added. During the 1930s and 1940s, every major dance band played at Playland Park, including the Dorsey Brothers, Cab Callaway, Kay Keyser, Ozzie Nelson, Duke Ellington, Harry James, Woody Herman, and Sammy Kaye. The ballroom was filled 7 nights a week, and crowds of 2,000 to 3,000 were common on weekends. The South Bend Blue Sox played many of their games at Playland Park during the 1940s and 1950s. Playland Park had a national reputation.

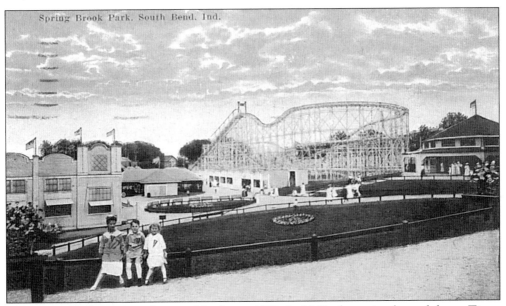

Spring Brook Park. South Bend. Ind.

The original ballroom was destroyed by fire in 1930. In 1941, the casino burned down. Times changed, and by the late 1950s, amusement park tastes had also changed. In 1962, Playland Park was turned into a lighted three par golf course. Later a miniature golf course was added. Then it lay unused for several years until Indiana University of South Bend purchased it with plans to make it a vital part of the growing university.

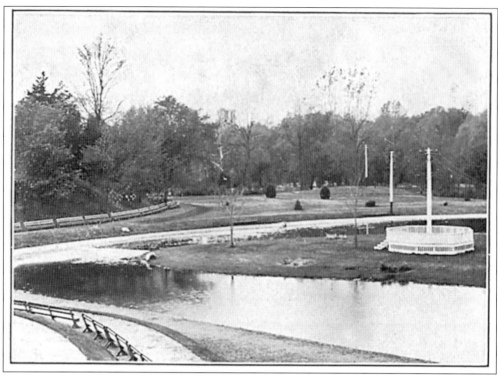

The Springbrook Creek was dredged out into a series of lagoons. Although it could provide an idyllic setting for a picnic, it could also be treacherous. Only 40 years earlier, the creek had overrun its banks during a serious midnight rain storm, tearing out the railroad bridge and sending an entire Northern Indiana & Southern Michigan Railroad passenger train into the deadly St. Joseph River. Although the exact number of people killed was never known, over 50 bodies were taken from the creek and river.

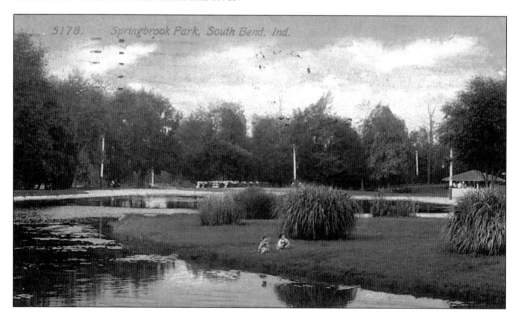

5178. Springbrook Park, South Bend, Ind.

COQUILLARD GOLF CLUB, SOUTH BEND, IND. 115992

The Coquillard Golf Club was built in 1923 near the intersection of North Ironwood Drive and McKinley Avenue. After a change in ownership, it became known as the Morris Park Country Club.

The Country Club of St. Joseph Valley was organized in April 1900. Its first home was the Eberhart farm, about four miles east of Mishawaka. The club remained there for three years, until it acquired a large part of the Byrkit farm just east of Mishawaka and bordering the St. Joseph River. The new club house was occupied on September 1, 1903. Sleeping quarters were available for those who wished to spend a few days in the country. In addition to the golf course, there were also tennis courts and croquet grounds.

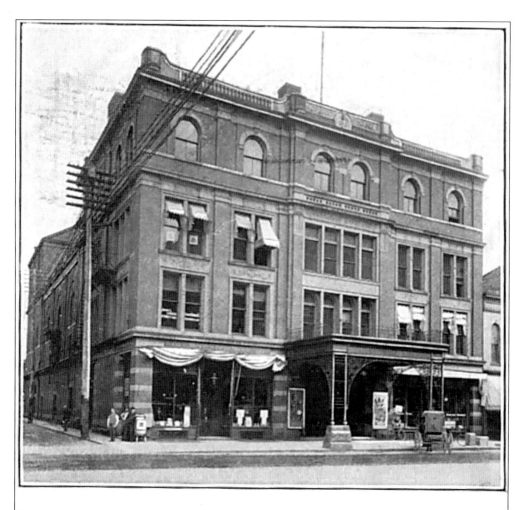

Oliver Opera House, South Bend, Ind.

Price's Theater and Good's Opera House had long been the major sources for theatrical attractions in South Bend. Both offered excellent entertainment, traveling shows, and nationally-known performers and speakers, including Buffalo Bill Cody, P. T. Barnum, and Clara Barton. But South Bend had grown a lot since those theaters had been established, and James and Joseph Oliver felt that it was time for South Bend to have a new, first-class opera house. In 1884, they spent $200,000 to build the Oliver Opera House at 116–118 North Main Street. The four-story red brick building opened on October 26, 1885. The public entered under a canopy of iron scrollwork, walked through plate glass doors into a vestibule of marble and cherry wood, and, finally, saw velvet gold draperies and a 1,600-pound crystal chandelier illuminated by gas. The theater could hold 1,253 people. It brought the best entertainment to South Bend and later entered into a rivalry with the newly constructed Auditorium Theater. The second and third floors held 18 suites of offices. The South Bend Public Library was located on the fourth floor from 1888 through 1896. In 1910, an additional 3 floors, containing 60 hotel rooms, were added. With the coming of motion picture theaters, the Opera House lost its appeal. By 1930 it, too, was showing motion pictures. In 1952, the theater was closed, and in 1955, it was torn down. The remaining office and hotel section was occupied until 1978, and the building was razed in 1980.

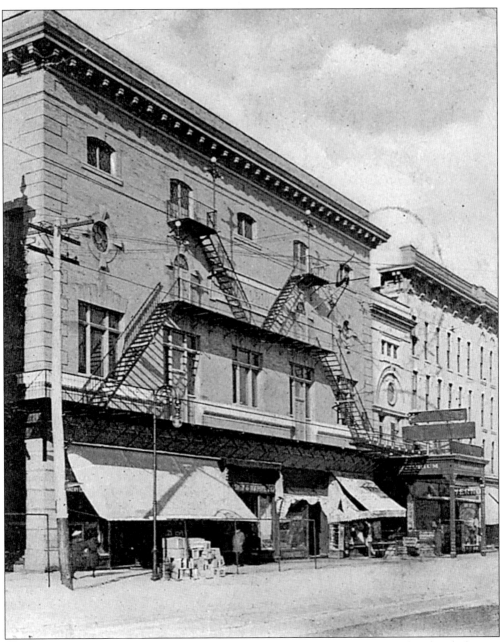

The Auditorium Theater was built in 1898 by the Studebaker family to rival the already famous Oliver Opera House; it drew in top name entertainment, including Sarah Bernhardt. The theater stood at 207 South Michigan Street, where Henry and Clem Studebaker had started their blacksmith shop and carriage works. The Auditorium was a 3-story, yellow-brick building, larger than the Oliver Opera House, and seated 1,635 people. The motion picture was beginning to dominate theaters, and by World War I, the glory of both the Auditorium and the Oliver had faded. The Auditorium was badly damaged by a fire on December 7, 1920. Although it was rebuilt as a moving picture theater, the Auditorium only had a short life. The building was demolished to make room for Robertson's Department Store.

Palace Theatre, The Home of Orpheum Vaudeville, South Bend, Ind.

The Palace Theater Building at 211 North Michigan Street opened on November 2, 1922. Like its earlier rivals, the Oliver Opera House and the Auditorium, it was designed to provide the best entertainment for South Bend's growing population. It was really two buildings in one. The Palace Theater provided an exceptional theatrical stage for vaudeville actors, road productions, and film entertainment. It could seat 2,700 people on the lower floor and another 1,400 in the boxes. The Palais Royale Ballroom provided room for dance bands, such as Benny Goodman and Gene Krupa, with plenty of space for couples to dance. As times changed, the Palais Royale fell upon hard times and was later turned into a dance hall for teenagers. At the same time, theatrical show productions began requiring larger stages and the Palace had no room to expand its stage. By 1959, people were talking about its certain demise, but E. M. Morris purchased the building and donated it to the city as a civic auditorium. Still, by 1990, people were again talking about how soon it would fall to the wrecker's ball. However, a multi-million dollar grant was obtained, the building completely refurbished, a neighboring building was torn down, and the stage expanded. Today, it is the Morris Performing Arts Center and is ready to meet another challenge.

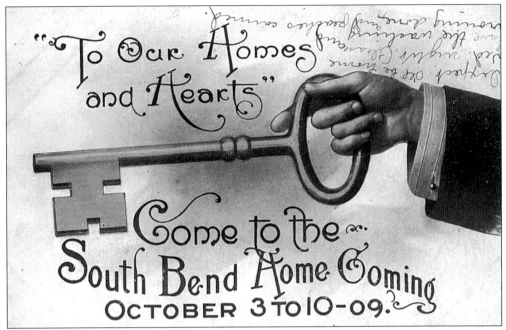

South Bend held a gala celebration on October 6–8, 1909. The Chamber of Commerce, along with business leaders and the Northern Indiana Historical Society, planned parades, ballooning, races, concerts, recitals, and more to lure former South Benders back for a few days of excitement.

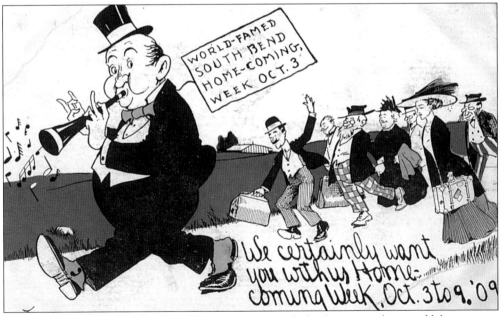

At the suggestion of the Chamber of Commerce, store clerks, factory workers, and laborers were given a half-holiday. Schools were closed for most of the week. A festive parade was given down Michigan Street, with an estimated crowd of 50,000 watching the parade. The *South Bend Tribune* ran daily articles on former South Benders who had registered at the Northern Indiana Historical Society. Three of Schuyler Colfax's sisters returned to South Bend for the event.

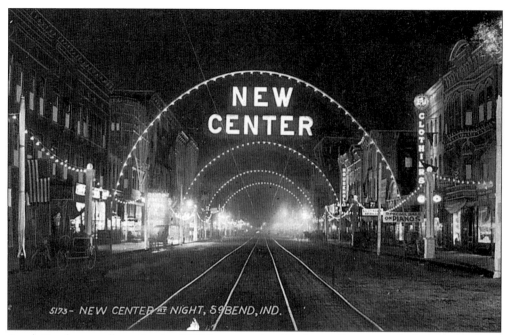

South Bend went all out for the 1909 homecoming. Michigan Street was decked in a series of lights and renamed New Center.

South Bend celebrated one of the quietest Fourth of July Celebrations in recent years in 1912. Springbrook Park provided the only celebration festivities. Nearly 10,000 people attended daytime and nighttime fireworks and listened to afternoon and evening band concerts. All of the amusement rides and booths were open. The St. Joseph River provided a great area for the floats.

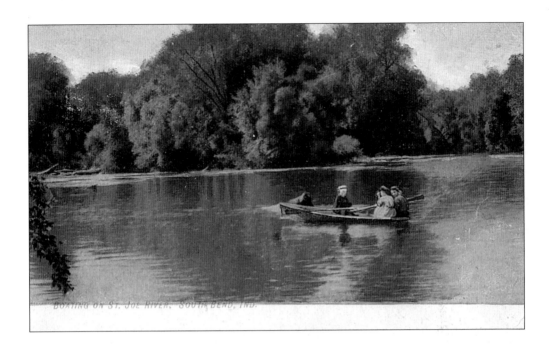

BOATING ON ST. JOE RIVER, SOUTH BEND, IND.

Boating excursions on the St. Joseph River have always been popular. Before the series of dams was installed to control flooding, boats could travel most of the river from central Michigan through Indiana and back into Michigan, where the river empties into Lake Michigan at St. Joseph. In pioneer times, paddleboats made regular trips up and down the river, carrying people and cargo.

STEAMER MILTON D. GOING UP ST. JOSEPH RIVER

Fishing was one of the main attractions of the St. Joseph River. Until the dams were built, large sturgeon from Lake Michigan regularly swam the St. Joseph River.

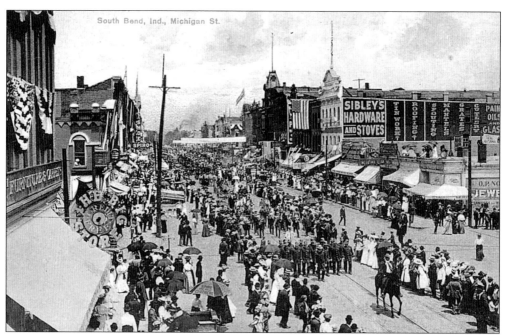

Parades were always popular with South Benders. Veterans' units, school bands, floats, and major companies almost always participated in each major parade. At the time, parades were not usually held on the Fourth of July; they were held on Decoration Day (now Memorial Day) and Armistice Day (now Veterans' Day).

WEISS FAMILY REUNION

You are cordially invited to attend the Annual Reunion of
the Weiss Family, to be held at

POTAWATOMI PARK, Section No. 3

AUGUST 29, 1926

Notify the relatives

Dinner at 1:00 o'clock sharp

MRS. H. E. PABST, Secretary

Postcards were a quick and inexpensive way to advertise family reunions. Postcards were sent out from Mishawaka on August 21, 1926, to announce an upcoming family reunion. Mrs. Henry Weiss received this invitation to the seventh Weiss family reunion for Sunday, August 29, 1926. A picnic dinner was served to 85 family members. Ulrich Weiss, of Mishawaka, age 85, was the oldest attendee. John H. Pabst, age 6 weeks, was the youngest attendee. His parents were Mr. and Mrs. Herman E. Pabst of South Bend.

Rum Village Woods has always proven to be one of South Bend's best-loved parks. For over a decade, the most popular attraction in the park was Storyland Zoo, a children's wonderland where small animals like sheep, goats, and ducks were housed in buildings that looked like pictures found in children's story books. A small miniature train ran around the zoo, carrying more than a dozen passengers, young and small. However, over time, the train proved too dangerous due to increasing motor vehicle traffic, and rising costs closed Storyland Zoo. The animals were moved to the Potawatomi Park Zoo.

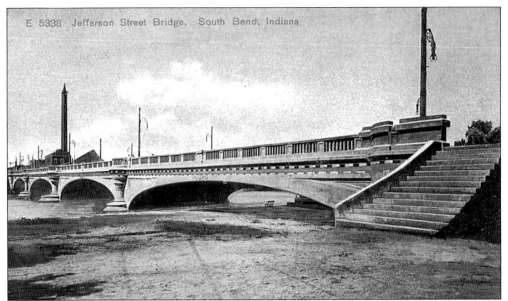

E 5338 Jefferson Street Bridge, South Bend, Indiana

The Jefferson Street Bridge is considered the crown jewel of South Bend's bridges and was dedicated on July 21, 1906 (the same day of the Studebaker Electric Fountain dedication). The eastern approach was designed to harmonize with the improvements in Howard Park. The 4 arches span 110 feet over the St. Joseph River. Both wooden and iron-truss bridges had been constructed on La Salle Street (then known as Water Street), Colfax Street (then known as Market Street), and several other streets, as well as on Jefferson Street. Wooden bridges proved to have a short life, and iron bridges expanded too much in severely cold or hot weather, resulting in complications and continuous upkeep. County commissioners chose to use a new system, called the Melan system, which combined a concrete arch with reinforced steel ribs buried in the concrete. The bridge was renovated in 2003 and 2004.

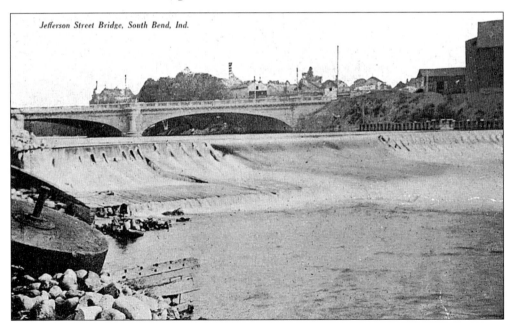

Jefferson Street Bridge, South Bend, Ind.

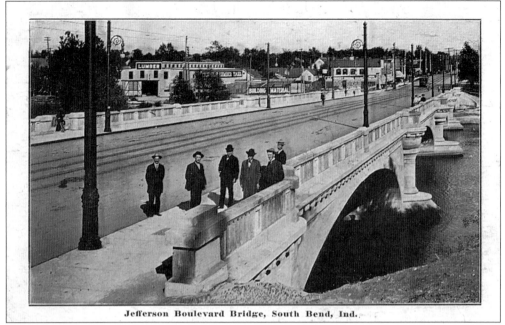

Jefferson Boulevard Bridge, South Bend, Ind.

Insets in the bridge allowed pedestrians to take their time and enjoy the beautiful views as they walked across the bridge. Just recently reconstructed, the bridge is still the city's crown jewel.

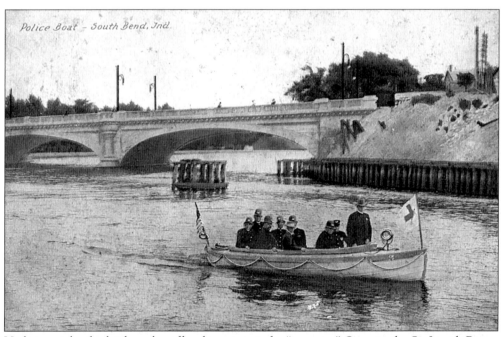

Police Boat – South Bend, Ind.

Unfortunately, the bridges also offered great spots for "jumpers." Once in the St. Joseph River, the strong current would take jumpers over the dam in a matter of seconds, and the strong undercurrents were deadly. Police boats regularly patrolled the waters and practiced their life-saving skills.

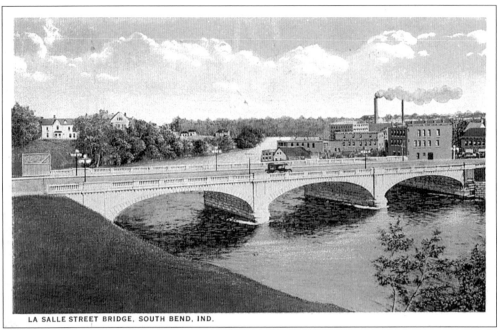

LA SALLE STREET BRIDGE, SOUTH BEND, IND.

The first bridge over La Salle Street (then Water Street) was an iron suspension bridge. It was replaced in 1885 by an iron truss bridge made by the Chicago Bridge and Iron Company. In 1906, this iron bridge was removed and floated down the St. Joseph River to Darden Road, where it still serves public needs. This concrete bridge was erected on La Salle Street in 1906.

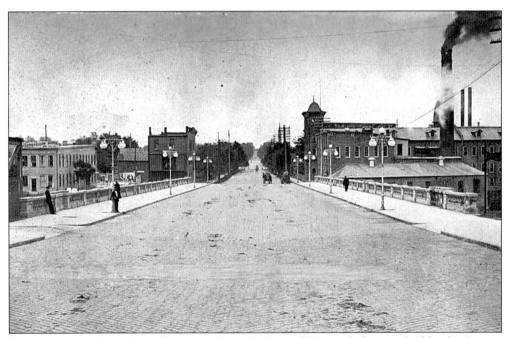

This panoramic shot of La Salle Street shows the beautiful street lights supplied by the George Cutter Company. Cutter was one of the largest street light manufacturers in the United States and sold lights internationally. The company was based in South Bend.

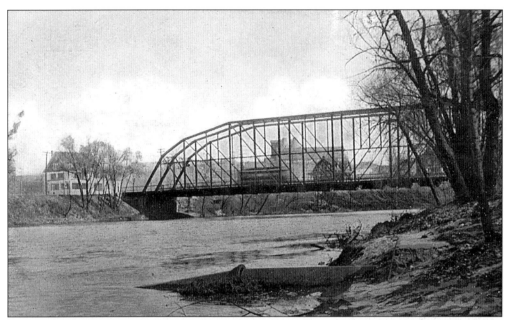

In February 1881, rains flooded the St. Joseph River and thawed a huge ice jam on the river, raising the river level about a foot above the dam. The ice blocks roared down the river, completely tore out the wooden bridge over Jefferson Street, pounded against the iron bridge over Market (Colfax) Street, and then sent their fury against the wooden Leeper bridge at the head of Michigan Street, crushing the wooden structure. Later that year, the wooden Leeper bridge was replaced with this iron truss bridge.

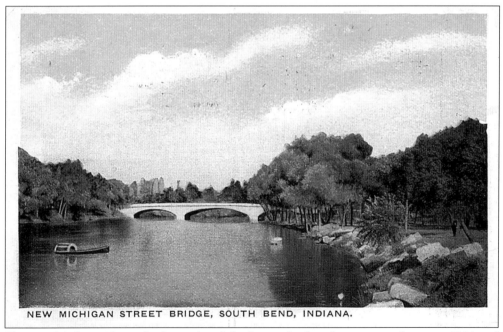

NEW MICHIGAN STREET BRIDGE, SOUTH BEND, INDIANA.

The new Michigan Street bridge replaced the Leeper bridge. Construction began in 1914 and finished in 1915. Keurt Construction Company of Indianapolis did the concrete work.

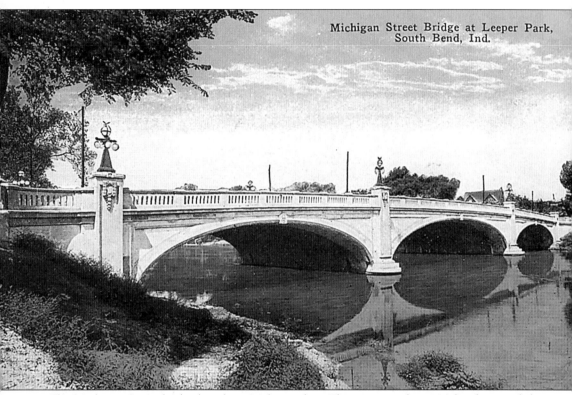

The Michigan Street bridge has three Melan arches. The center arch is 116 feet long and the 2 smaller spans are each 80 feet. The street lights were manufactured by the George Cutter Company. The bridge was renovated in 1976.

SOUTH BEND
CROSSROADS OF COMMERCE

The MAKING OF AMERICA Series

OUR 4th ANNUAL PUMPKIN SHOW

Get a Membership
in the
CHAMBER OF COMMERCE

JOHN PALMER

We hope you've enjoyed this brief review of South Bend's history through vintage postcards. For more information on South Bend's great history, you can find all of these books published by Arcadia: *South Bend: Crossroads of Commerce* (John Palmer); *South Bend, Indiana* (Kay Danielson); *German Settlers of South Bend* (Gabrielle Robinson); *Baseball in South Bend* (John Kovach); *Southern St. Joseph County* (Franklin N. Sheneman II), and *Saint Mary's College* (Amanda Divine and Colin-Elizabeth Pier).

BIBLIOGRAPHY

Anderson and Cooley (compilers). *South Bend and the Men Who Have Made It. Historical, Descriptive, Biographical.* South Bend: Tribune Printing Co., 1901.

Ault, Phil H. *South Bend Remembers: A Newspaper History of Old South Bend.* Decatur, IL: Spectator Books, 1977.

Howard, Timothy Edward. *A History of St. Joseph County, Indiana.* Chicago: Lewis Publishing Co., 1907.

Michiana Memories. A Selection of Historical Articles from Michiana, the South Bend Tribune's Sunday Magazine. South Bend: Northern Indiana Historical Society, 1980.

South Bend City Directories. South Bend: Various publishers, 1900–1959.

South Bend Tribune, 1873–the present.

Talley, J. Edward. *Leeper Park. South Bend's First Historic Designed Landscape Landmark.* Prepared expressly for the Park Commission of South Bend, Indiana; the South Bend Common Council, and the Historic Preservation Commission of South Bend and St. Joseph County, 1996.